THE COMPROMISED LAND

THE COMPROMISED LAND

--

RECENT PHOTOGRAPHY AND VIDEO FROM ISRAEL

Edited by HELAINE POSNER and LILLY WEI

BOAZ ARAD -- YAEL BARTANA -- JOSEPH DADOUNE -- NIR EVRON -- BARRY FRYDLENDER --
DANI GAL -- ORI GERSHT -- DOR GUEZ -- ODED HIRSCH -- MIKI KRATSMAN -- SIGALIT LANDAU --
DANA LEVY -- SHAHAR MARCUS -- ADI NES -- NIRA PEREG -- GILAD RATMAN --
MICHAL ROVNER -- LIOR SHVIL -- SHARON YA'ARI -- RONA YEFMAN and TANJA SCHLANDER

With essays by ORY DESSAU, HELAINE POSNER,
RON PUNDAK and LILLY WEI

NEUBERGER MUSEUM of ART of
PURCHASE COLLEGE, SUNY

This publication accompanies the exhibition *The Compromised Land: Recent Photography and Video from Israel,* curated by Helaine Posner and Lilly Wei and organized by the Neuberger Museum of Art of Purchase College, State University of New York, August 11 through December 1, 2013.

Support for the exhibition is provided by Artis, Helen Stambler Neuberger and Jim Neuberger, Susan and James Dubin, and the Office of Cultural Affairs, Consulate General of Israel in New York. Additional funding is provided by the Friends of the Neuberger Museum of Art and the Purchase College Foundation.

Published by the Neuberger Museum of Art

Neuberger Museum of Art
Purchase College
State University of New York
735 Anderson Hill Road
Purchase, NY 10577
914-251-6100/6118 or
www.neuberger.org

ISBN 978-0-9795629-6-9

Designer
Beverly Joel, pulp, ink.

Editor
Ryan Newbanks

Proofreader
Samantha Waller

Printed and bound in Italy

Front Cover:
Joseph Dadoune
Ofakim, 2010
Video (color, sound), 14:47 minutes
Collection of the artist

--

BOAZ ARAD

BRAVERMAN GALLERY, Tel Aviv

CHELOUCHE GALLERY FOR CONTEMPORARY ART, Tel Aviv

COLLECTION OF CASEY AND ELLEN COGUT

JOSEPH DADOUNE

COLLECTION DANNY FIRST, Los Angeles

FREYMOND-GUTH FINE ARTS, Zurich

ORI GERSHT AND CRG GALLERY, New York

THIERRY GOLDBERG GALLERY, New York

DOR GUEZ AND DVIR GALLERY, Tel Aviv

THE JEWISH MUSEUM, New York

MIKI KRATSMAN

SIGALIT LANDAU

THE LEWKOWITZ FAMILY COLLECTION

ANDREA MEISLIN GALLERY, New York

ADI NES AND JACK SHAINMAN GALLERY, New York

MICHAL ROVNER AND YAD VASHEM, Jerusalem

LIOR SHVIL

SOMMER CONTEMPORARY ART, Tel Aviv

--

FOREWORD

The Compromised Land: Recent Photography and Video from Israel is the first exhibition in the history of the Neuberger Museum of Art of Purchase College to introduce contemporary art made in Israel to our audiences. We are eager to enjoy the work of these artists and honored to be able to learn about their focus, aspirations, and achievements.

Curated by the Neuberger Museum's Senior Curator of Contemporary Art, Helaine Posner, with guest curator Lilly Wei, the exhibition brings together artists who are directly and deeply engaged in interpreting the cultural and social dynamics of the place in which they live, through the lenses of personal experience and a critical reading of history. Rooted in daily life, their artworks take special form in the media of photography and video, which, in turn, convey a singular concomitance of existential urgency and poetry. The exhibition offers a poignant look at a young nation, its historical and socio-political complexity, and its economic and cultural ambition.

The Compromised Land introduces artists whose work is developed through critical views but rooted in emotional investment. It continues the Neuberger Museum's commitment to social consciousness as embodied in the work of contemporary artists. The Museum is a place of learning and discussion for Purchase College students and all audiences through exemplary and daring works of art. *The Compromised Land* also fosters the study of new media and sheds light on how artistic discovery can grow from the powerful intertwinement between experience and the expressive qualities of the moving image.

We are indebted to many enthusiastic supporters who embraced this project since its very inception.

We thank Thomas J. Schwarz, President of Purchase College, and Dr. Barbara B. Dixon, former Provost and Executive Vice President for Academic Affairs, for their heartfelt participation in the Museum's life and activities. We salute newly appointed Provost and Vice President for Academic Affairs Barry Pearson, who begins at the college as the exhibition opens to the public. We also extend our appreciation to Purchase College students, faculty, and staff, whose ideas and presence always inform our work.

The Consulate of Israel in New York, through the auspices of Anat Gilead, Consul for Cultural Affairs in the US, and Liran Golod, Director of Visual Arts and Literature at the Office of Cultural Affairs, contributed a grant in support of research and writing for this exhibition. We are grateful for their partnership.

Artis--an independent nonprofit organization that broadens awareness of contemporary art from Israel--invited Posner and Wei to its curatorial travel and research program and also generously supported this publication. We thank Artis's founder, Rivka Saker, Executive Director Yael Reinharz, and Program and Development Manager Tali Cherizli for their dedication to making this exhibition possible.

Gilad Ratman is the artist in residence at Purchase College School of Art and Design in conjunction with *The Compromised Land*. We thank Marge Goldwater, consultant at the Schusterman Visiting Artist Program, and our colleague Ravi S. Rajan, Dean of the School of the Arts, for this fruitful partnership. Support for the residency is provided by Purchase College Foundation and the Israel Institute, which is dedicated to enhancing knowledge and study of modern Israel. Support was also provided by UJA-Federation of New York in Westchester.

The Compromised Land received additional support from Purchase College Foundation as well as from the Friends of the Neuberger Museum of Art. Funds from the Friends comprise the most substantial support to the Museum's exhibition and educational programs, and we are ever grateful to our Friends members as well as to our Friends Board, who provide dedicated guidance, expertise, and feedback. In particular, we express our deep appreciation to Friends of the Neuberger's Chair Helen Stambler Neuberger and board member Jim Neuberger, and to Vice-Chair Susan Dubin, with her husband Jim Dubin, who generously provided additional support to this exhibition and whose vision significantly strengthens this institution.

Last but not least, I join Posner and Wei in their thanks to all the lenders to *The Compromised Land*, listed on page 7, for allowing our audiences to enjoy these significant photographic and video artworks. Among the lenders are the artists whose works are featured here and who make *The Compromised Land* a unique insight into their artistic world.

--Paola Morsiani
Director
Neuberger Museum of Art of Purchase College

ACKNOWLEDGMENTS

We are truly grateful to the organizations and individuals, particularly the artists, that helped make this international survey exhibition of recent photography and video by Israeli artists a reality. The curators wish to thank our colleagues at Artis for inviting us to participate in one of their biannual curatorial research trips to Tel Aviv and surrounding cities. This was an unparalleled opportunity to engage with Israeli artists and the larger Israeli art community, and provided the impetus for this exhibition. Founder and Chair Rivka Saker; Executive Director Yael Reinharz; and their able staffs in New York and Tel Aviv generously offered advice and support throughout the subsequent planning process. We wish to thank Anat Gilead, Consul for Cultural Affairs in the United States; and Liran Golod, Director of Visual Art and Literature at the Consulate General of Israel in New York, for their valuable assistance in bringing this project to fruition.

We extend our appreciation to the private collectors, museums, galleries, and artists who have kindly loaned works from their distinguished collections. They include: Casey and Ellen Cogut; Danny First, Los Angeles; The Lewkowitz Family Collection; The Jewish Museum, New York; Braverman Gallery, Tel Aviv; Chelouche Gallery for Contemporary Art, Tel Aviv; Freymond-Guth Fine Arts, Zurich; Thierry Goldberg Gallery, New York; Andrea Meislin Gallery, New York; Sommer Contemporary Art, Tel Aviv; Ori Gersht and CRG Gallery, New York; Dor Guez and Dvir Gallery, Tel Aviv; Adi Nes and Jack Shainman Gallery, New York; Michal Rovner and Yad Vashem, Jerusalem; Boaz Arad; Joseph Dadoune; Miki Kratsman; Sigalit Landau; and Lior Shvil.

We offer our sincere thanks to Ory Dessau, art critic and curator, for his insightful essay exploring the work created by artists included in *The Compromised Land* from an Israeli perspective, and to Ron Pundak, Israeli historian and chairman of the Israeli Peace NGO Forum, for eloquently describing the broader context in which it was created. Ryan Newbanks edited this book with his usual sensitivity and skill, and Beverly Joel of pulp, ink. is responsible for its elegant design.

At the Neuberger Museum of Art, Avis Larson, Assistant Curator, and Pat Magnani, Registrar, handled exhibition loans, image collection, and shipping arrangements with efficiency; and Jacqueline Shilkoff, Curator of New Media, provided technical expertise. David Bogosian, Chief Preparator, and Jose Smith, Associate Preparator, and their team installed the exhibition with professionalism; and Olivia Kalin, Curator of Education, organized related educational events. Our thanks go to Tracy Fitzpatrick, Chief Curator, and Paola Morsiani, Director, for their encouragement and support. We also wish to thank Ravi Rajan, Dean of the School of the Arts at Purchase College, for partnering with the Neuberger Museum of Art to bring Gilad Ratman to campus as part of the Schusterman Visiting Israeli Artist Program, and the artist for his contributions to academic life this fall.

Our deepest gratitude goes to the artists whose work is featured in *The Compromised Land*. We thank Boaz Arad, Yael Bartana, Joseph Dadoune, Nir Evron, Barry Frydlender, Dani Gal, Ori Gersht, Dor Guez, Oded Hirsch, Miki Kratsman, Sigalit Landau, Dana Levy, Shahar Marcus, Adi Nes, Nira Pereg, Gilad Ratman, Michal Rovner, Lior Shvil, Sharon Ya'ari, and Rona Yefman with Tanja Schlander, for sharing their visions with us.

--Helaine Posner and Lilly Wei

THE COMPROMISED LAND

RECENT PHOTOGRAPHY AND VIDEO FROM ISRAEL

HELAINE POSNER AND LILLY WEI

Helaine Posner is Senior Curator of Contemporary Art at the Neuberger Museum of Art of Purchase College.
Lilly Wei is a New York-based independent curator and critic whose focus is contemporary art.

The Compromised Land: Recent Photography and Video from Israel revolves around the notion of *land*, which in Israel has always been synonymous with Israel, as much a concept as it is a physical measure. Land, *Eretz Yisrael*, is a sacred as well as a geographical, economic, social, and political entity rooted in thousands of years of history, and in the psyche and culture of its peoples. In the name of the land, heroic but at times also dishonorable deeds have been done. This exhibition and catalogue take a look at Israel through the intellectually and emotionally invested eyes of some of its most remarkable artists. Their work gives voice to a sense of un-settlement and existential threat through the expression of internal and external discord, as the artists explore Israel and Israeli politics and culture with urgency, criticality, questions, and an abiding, if complicated, love for the land.

The Compromised Land brings together a selection of works that underscore the shift from the utopian goals of the first generation of Israelis to the escalating complications and disillusion-ments expressed by present generations, as they grapple with a host of issues through the lens of the political, the nationalistic, the militaristic, the social, the religious, and the personal. It is also a specific examination of Israeli photography and video, practices that dominate con-temporary Israeli art and for which it is internationally recognized.

The exhibition is organized around three themes that recur in the featured artworks and that play a significant role in the life and consciousness of Israel. They are: co-existence, addressing conflict and the country's ongoing tensions and uneasy multiculturalism; history, as it be-comes intertwined with memory in a state that is at once very old and very young; and the tremendous importance of the land. The featured artists, who range from the well-established to those now emerging on the international scene, include Boaz Arad, Yael Bartana, Joseph Dadoune, Nir Evron, Barry Frydlender, Dani Gal, Ori Gersht, Dor Guez, Oded Hirsch, Miki Kratsman, Sigalit Landau, Adi Nes, Nira Pereg, Gilad Ratman, Michal Rovner, and Sharon Ya'ari. A screening program showcasing video work by artists Dana Levy, Shahar Marcus, Lior Shvil, and Rona Yefman with Tanja Schlander further explores the themes of the exhibition and introduces new and recent artworks.

History and memory, and settlers and the land, are two of the three tightly interwoven catego-ries of this exhibition. Seen from multiple perspectives through the eyes of two generations of Israeli artists born in the mid-1950s to the mid-1970s, the former category is represented by Boaz Arad, Yael Bartana, Dani Gal, and Michal Rovner, the latter by Nir Evron, Sigalit Landau, Oded Hirsch, Gilad Ratman, and Sharon Ya'ari. No longer considered peripheral--all our des-tinies have proven to be inextricably linked and contingent--these Israeli photographers and video artists have earned international recognition for the originality and eloquence of their vision, one that is resolutely culturally specific but also universally resonant.

--

The land of Israel, roughly the size of the state of New Jersey but symbolically of incalculable measure, has a current population of almost eight million, approximately seventy-six percent Jews and twenty percent Arabs (both Muslim and Christian), with four percent unaccounted for. It is a site of conflict both ancient and new. Its more recent timeline--a relative term--includes the flight of large numbers of Eastern European Jews to Palestine in the 1880s, a region they considered to be their cherished ancestral home and the site of the utopian *Altneuland* imagined by Theodor Herzl, the father of modern Zionism. The modern nation of Israel was founded in 1948; ecstatically celebrated by the newly denominated Israelis, it is a date the dispossessed Palestinians called *al-Nakba*, the catastrophe. From then to the present, there has been continuous, tumultuous strife, the success of one the despair of the other: the 1967 Six-Day War; the 1973 Yom Kippur War; the first and second intifada; the controversial erection of the wall between Israel and the West Bank begun in 2002; the Israeli withdrawal from Gaza in 2005; the 2006 Israeli-Lebanese War; and so much more.

During these years, Israel has transformed itself from an agrarian to a prosperous, highly sophisticated, technological society. In a recent article about technical innovation in Israel, the late Israeli journalist Amnon Dankner observed that Israel seems to believe that it exists in a virtual realm outside the fraught geography and circumstances of the Middle East.[1] But, of course, it does not. Citing Dankner in a *New York Times* op-ed, Thomas L. Friedman went further to note that if rockets arrive from Gaza in the morning, venture capital arrives from London in the afternoon. The Israeli ability to live between that divide, between the good life and apocalypse, was "impressive and necessary" but also "illusory and dangerous."[2] In cosmopolitan Tel Aviv, Haifa, and Jerusalem, there is a tendency to block out the civil war raging nearby in Syria; the clashes in Cairo and between Turkey and Iran; the bitterness of the Palestinians in the West Bank and Gaza and the very possible eruption of a third intifada. There is incipient tragedy in the current constellations.

Seemingly less burdened by their traumatic history and the sense of marginalization that remained until the 1990s when the Arab boycott collapsed, digital media flourished, and air travel became the norm, contemporary Israeli artists, such as the ones in this exhibition, regard their entangled heritage more ambiguously, with greater critical distance, less fiercely vested in the no longer--if ever--tenable Zionist dreams of their grandparents and parents. As settlers replaced kibbutzniks and settlements became more and more entrenched, the sovereignty of Israel's secularism has been attacked by the fervently religious right, abetted by a military that is increasingly made up of religious Zionists. Israeli policies have become increasingly skewed by the intolerance and extremism of the country's conservatives, moving away from the egalitarianism proclaimed at its foundation, a slide from victim to oppressor, from a democratic society to a police state a looming danger.

--

Boaz Arad has said that the one consistent thread in his practice is to regard and explicate history from a personal point of view. His presentation is critical, ironic, and ethical--an examination of the post-Holocaust diversity of contemporary Israeli society. He describes his video *Kings of Israel* (2009) as inspired partly by certain collections in the British Museum, in London, that are the legacies of British travelers who wandered the Empire in the days of its glory. Arad created his own collection of curious, personally resonant objects. Although displayed on shelves, they embody "knowledge that cannot be arranged meaningfully," he said. In one scene in the video, Arad takes apart a gun that belonged to his father, a member of Shin Bet (General Security Services), who had received it from his father, who was in the Haganah, the Jewish paramilitary organization, the predecessor of the Is-

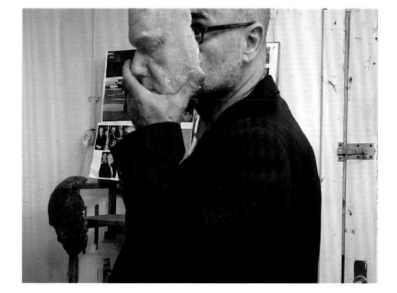

Boaz Arad
Kings of Israel, 2009
Video (color, sound),
9:30 minutes

raeli Defense Forces. Arad assumes the guise of Yigal Amir, the religious Yemenite Jew who assassinated Prime Minister Yitzhak Rabin in 1995, whose guise he also assumes, in essence killing himself. The reenacted failure to protect Rabin becomes a personal failure, a family failure, perhaps a national failure. At the moment when the Kings of Israel Square was transformed into Rabin Square, the kings are forgotten, replaced by the memory of Rabin, Arad explained to the curators in an interview in Tel Aviv in July 2011. In essence, then, history is mutable and yields to the present. This film, as well as his other film featured in the exhibition, which was made in collaboration with Miki Kratsman, are both about failure, including the failure of art, of critique, of democratic principles, and the ability to generate historical knowledge.

Yael Bartana has produced some extraordinary parables as documentary-style films about Israel and its Eastern European heritage, Zionism, and the repercussions of its 60-odd years of existence. One of her most frequently exhibited works has been *Trembling Time* (2001), filmed in Tel Aviv on Israel's National Memorial Day (*Yom Ha-Zikaron*), the annual commemoration for those soldiers who died defending their country and once an emblem of solidarity. It is marked by the high, two-minute wail of air-raid sirens across the country, bringing everything to a standstill for a moment of silence. The slow-motion, one-shot *Trembling Time* was filmed looking down from an overpass onto a busy highway at night, headlights the primary source of illumination while the artist's use of cross-fade editing and repetition create a layered, ghostly effect. As traffic comes to a halt, the drivers emerge from their cars one by one to stand for the ritual moment of silent reflection that Bartana's camera records with an aestheticized detachment which nevertheless manages to convey sympathy. In *Mary Koszmary* (Nightmares;

2007), the first installment--and perhaps the most riveting--of her Polish trilogy, Bartana creates a fictional world in which Polish Jews have banded together to form a Jewish Renaissance Movement. The film begins with a tall young man in a black leather coat (Poland's leftist author and political activist Slawomir Sierakowski) striding into the abandoned National Stadium in Warsaw. Ascending a ramshackle platform, he proclaims to a pointedly tiny audience of youthful scouts: "Let the three million Jews that Poland has missed . . . return to Poland, to your country." Acknowledging Poland's history of deadly anti-Semitism, he argues that Jews and Poles together can overcome the horrors of the past to produce a new, more vigorous and enlightened nation: "We need the other, and there is no other closer to us than you are! Come!" Sierakowski's speech also echoes the Zionist call for world Jewry to immigrate to Israel, today another explosive issue that invokes Israel's need to engage with its own "others."

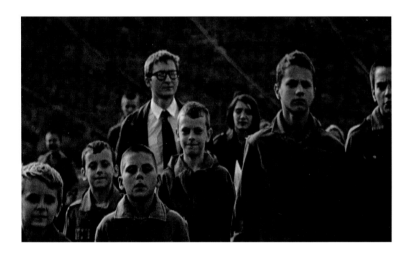

Yael Bartana
Mary Koszmary (Nightmares),
2007
16mm film transferred
to video (color, sound),
10:50 minutes

The title of Dani Gal's *Nacht und Nebel* (*Night and Fog*, 2011) is a phrase from Wagner's *Das Rheingold*, which recalls Alain Resnais' powerful 1955 documentary *Nuit et Brouillard*, about Auschwitz and Majdanek, which in turn refers to the 1941 "Nacht und Nebel" directive that determined the fate of political activists and others considered a threat to German security. At the Nuremberg trials, the actions taken under that directive were judged a violation of the Hague Conventions and international law. Pointedly, the narrative of Gal's *Nacht und Nebel* commences on April 11, 1961 with the trial of Adolf Eichmann. Tried in an Israeli court and charged with war crimes and crimes against humanity, Eichmann was convicted and executed by hanging on May 31, 1962. In the wee hours between May 31 and June 1, 1962, immediately after his cremation, a select group of police officers sailed from the Jaffa port, its mission to scatter Eichmann's ashes six miles out to sea in the international waters of the Mediterranean. That way, there would be nothing left, nothing for a future memorial, no place for supporters to gather, and no nation to shelter his remains. Gal interviewed Michael Goldman, a Holocaust survivor and one of the policemen who conveyed the ashes, and his film enacts a staging of that momentous, surreptitious voyage in the dead of night, in darkness and fog, a solemn ritual of closure that was also an adaptation of the Nazi policy of disappearance, poetic justice for Eichmann's murder of millions.

Michal Rovner's signature work in video, sculpture, and installation strives for the timeless and associational, her politics filtered through the poetic. She choreographs great masses of people into patterns that are both controlled and chaotic. Her works are at times almost ar-

cheological, the imagery shuttling between the abstract and representational, suggesting epochal swaths of time and space. The work presented here, *To Be a Human Being* (2007), is a departure of sorts for Rovner, composed of fairly straightforward segments of entwined filmed interviews with ten elderly women who live in Jerusalem and are Holocaust survivors, the commentary intercut with trees and other images of serenity and continuity. Recounting their stories, they describe how, as young women, they survived the concentration camps, speaking of their sense of community with the other sufferers, their defiance and unflagging will to live, and the inspiration and solace of art. Rovner had created a permanent video installation, *Living Landscape* (2005), for Yad Vashem, the Holocaust Martyrs' and Heroes' Remembrance Authority in Jerusalem. In it, she painstakingly recorded the daily life of Eastern European Jews from archival film footage and photographs, producing a portal to a vanished world that Rovner has called "the work of a lifetime, a great and daunting responsibility." In it, she did not want to "dwell on death, but on life, celebrating a spirit that might still prevail."[3] That same spirit of prodigious life illuminates these very poignant, vulnerable interviews, their testimony still vivid, among the most purely documentary of the exhibition.

Dani Gal
Nacht und Nebel
(Night and Fog), 2011
Video (color, sound),
22 minutes

In Virgin Land (2006), a video by Nir Evron, is a breathtakingly beautiful meditation on place. Evron panoramically scans the ancient land, shown empty of people and framed to evoke its past as well as present incarnations. In recent years, his work has replicated earlier documentary styles using film, archival materials, text, and sound to convey the sense of another century as well as the land's endurance and its indifference to ephemeral human presence. Filmed in 2006 throughout Israel, from Lake Hula in the north to the Negev in the south, there is no indication of the 21st century. Some of the vistas presented were pioneering photographs and films from the late 1800s and digitally manipulated, as was all the footage, erasing any indication of dates. The text for the voiceover narration was taken from the diaries of celebrated 19th century scientists, writers, soldiers, pilgrims, and travelers, among them Gustave Flaubert, Herman Melville, and English clergyman and Oxford scholar Henry Baker Tristram. It also includes commentary from visitors from much earlier periods, spanning more than one thousand years, which together suggest the shaping of an impassive landscape through changing human consciousness. The narrative purports to be of a six-day journey across the land--Palestine or Israel--which roves between discussions of its climate, flora, fauna, its topography, and its aesthetic points of interest, while the relationship between image and text is seldom in synch. But the text is a collage, a fiction pieced together from ten different sources,

the seamlessness of the journey a construct. And the unvoiced, invisible text refers to the plight of contemporary Israel, a construct of another order, its integrity threatened by conflicts that might shatter it.

Sigalit Landau's video *Azkelon* (2011), more overtly political, was filmed on a beach between Gaza and Ashkelon, in an area where political tension runs high--although political tensions run high throughout the country; it has been the target of bombardments by Hamas and the site of retaliatory strikes by Israel. The area is beautiful, the history of the city of Ashkelon venerable, extending back to the time of the Canaanites (with a Neolithic site nearby) and mentioned in Egyptian texts of the 11th Dynasty. Landau's allegorical, installational, and performative work almost always includes water, salt, earth--the constituents of place. (The artist once said that "relevant and irrelevant borders" are her subjects.)[4] An emblem of political divisions and religious conflicts in Israel, Landau's *Azkelon* focuses on the popular knife game of the region, played in the sand by a group of silent, deeply intent boys. Their knives cut through the shifting ground, itself a metaphor and ironic: the sand is an unstable foundation. The constant re-drawing of borderlines, part of the game, is also symbolic of the reality of the region's changing, susceptible borders and cultural and political collisions--the violence implied by the flash of the knives in the sand. Landau is optimistic about eventual resolutions, saying, "where there is play, there is life . . . there is the possibility of interaction." Her knives are controlled, wielded according to established rules. Writing about this recent body of work in a notebook, she offered these fragments: "video drawings in the sand. no sky line. water meets shore. people arrive at this poetic arena/format. where body water and movement dwell. normally a place of retreat."

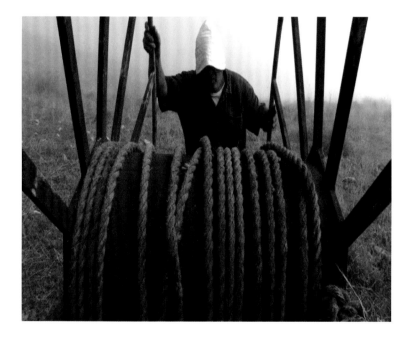

Oded Hirsch
Tochka, 2010
Video (color, sound),
13:20 minutes

Oded Hirsch's *Habaita* (2010) is a kind of group portrait of approximately twenty persons of various ages in a simple wooden boat--almost all are standing, without movement. Floating on a body of water, the boat forms its own little island, a contemporary ark that does not seem to offer much shelter. The video is silent except for the snap of wind and the lap of water. The camera scans a few faces at a time, their expression impassive, zooming in and then retreating to a full view to encompass the surroundings, only as a generalized, timeless space. Since it's a work by Hirsch, we assume we are near the kibbutz where he was raised--its stoic inhabitants and their close-knit, agrarian life are the ongoing subjects of his videos and photographs.

His work explores the relationship of the individual to the community, the community to the land, and the labor-intensive tasks that are performed together to preserve both, although the actions Hirsch conceives for them seem pointless, even absurd. Hirsch's documentary-like films are surprisingly poetic, capturing a community that seems removed from contemporary life but rooted in a sense of place, sustained by its own age-old verities. More topically, it offers a comparison between today's controversial settlers and earlier rural communities, the Zionist history of Israel and the fragile current situation. In *Tochka* (2010), a group of men in dark blue clothing and white cotton caps--garb that makes the scene resemble an Ingmar Bergman allegory--wheel a giant rusty spool across a hilly landscape, using it to construct a rickety footbridge over a small ravine that could be easily crossed on foot. Hirsch has remarked, referring to his protagonists, that he is fascinated first and foremost by the social and communal endeavor itself.

Gilad Ratman's *The Boggy Man* (2008), which sounds like *boogie man* and will also disturb your dreams, opens with a primordial landscape of sinkholes, quicksand, and sludge. A creature called the Boggy Man is struggling in the morass and seems on the verge of drowning, about to be sucked into oblivion. While not a straightforward commentary on politics, social issues, or the land, the video lends itself well to conditions of near death and metaphor that aren't far from contemporary reality. Ratman's pyrotechnic imagination has often featured aquatic humanoids slogging through marshlands or other primal environments, their audacious, id-driven behavior uncivilized, unfettered, reactive. Ratman once said that he likes to push narrative to its boundaries, allowing for a fractured chain of events to take place, functioning as a vehicle that allows him to rub the real against the fictive. With comic verve, Ratman violates the correlation between cause and effect; his videos resemble unreliable narrators, subverting trust in the medium. As an idiosyncratic auteur, he can do what he wants, reminding us that they are his films, agents of truths, agents of lies.

Less fantastical, Sharon Ya'ari focuses on urban places that are usually overlooked, abandoned, of little current interest. He photographs sites he has designated "boring," by which he means simply that they are not spectacular; they have little that captivates. Yet from that reticence, renouncing spectacle, he draws out a multitude of signs and vestiges that bear subtle, if after-the-fact, testament to a neighborhood, a city, even a country--his point of view more philosophical than journalistic, although seemingly documentary in style. They are meticulously made, often monochromatic, and very quiet, elegant, in contrast to the clamor that characterizes metropolises in general and Israel as a culture and a place. In *Rashi Street* (2008), the scene more charged than usual, there is an ominous cloud of dust that billows down a city street, the cause unknown, which in Israel, more so than in some other countries, is always cause for alarm. In another photograph, there are two riders on horseback before the prison

--

they are patrolling on the city's outskirts, a watchtower looming in the background, the seemingly bucolic site in decline, underscored by the images themselves, reminiscent of Romantic 19th-century paintings with an ambience of rift, regret, foreboding. And in *Tel Aviv* (2010), Ya'ari presents a panoramic view of the rational, modern European city built on the sands beyond the older Arab city of Jaffa, the architectural disparities embodying the sociopolitical divisions that rend Israel. As Ya'ari's images achieve critical mass, as the details in his photographs accumulate, their passivity vanishes and the philosophical becomes more interrogative, a more critical witness.

The history of the state of Israel is characterized by constant conflict and an anxious multiculturalism. These themes are represented in *The Compromised Land* by the work of Barry Frydlender, Adi Nes, Nira Pereg, Boaz Arad, Miki Kratsman, Ori Gersht, Joseph Dadoune, and Dor Guez. As a geopolitical site, the Middle East is often defined by a set of deeply-rooted, binary oppositions that divide Arab from Jew, Palestinian from Israeli, East from West, religious from secular, center from periphery. And while conflict is an undeniable fact of life in the region, a closer look reveals a far more complex and contradictory reality within a Jewish state that is, in fact, a multicultural and multilingual society--one in which tensions often run high. As noted, of a current population of almost eight million people, approximately seventy-six percent are Jewish, about twenty percent are Arab, and four percent claim other backgrounds. The Arab population is predominantly Sunni Muslim, with a small minority of Shia and Druze, and a significant minority of Christians of various sects. Israel's official languages are Hebrew and Arabic, while English has semi-official status, and Russian, though unofficial, is spoken by about twenty percent of Israel's more recent wave of immigrants.

The military plays a central role in Israeli society, with mandatory service required of most citizens. Photographers Barry Frydlender and Adi Nes look at this institution from viewpoints that range from the panoramic to the personal. Frydlender typically examines contemporary Israeli life, from everyday experience to extraordinary events, in works that are both technically innovative and deeply observed. Though they initially appear seamless, the artist's large-scale color images, in fact, are digitally assembled from as many as hundreds of individual shots taken from different vantage points at different times, creating a visual document that is as much constructed as it is real. In the monumental *Shirat Hayam ("End of Occupation?" Series #2)* (2005), Frydlender depicts the military evacuation of Israeli settlers from the Gaza Strip in an image that appears at once timeless, even Biblical, and contemporary, re-presenting an incident likely seen on the nightly news. In his "Soldier" series (1994–2000), Adi Nes explores issues of Israeli identity and masculinity in photographic tableaux that evoke the religious iconography of Renaissance and Baroque art. As a gay man and a Sephardic Jew from Iran, Nes recalls feeling like an outsider within Israel's European-dominated, macho culture

--

while also being captivated by the beauty of the youthful male soldier. In a nod to Leonardo da Vinci's great work, the artist staged and photographed a scene that suggests a last supper before going to battle (1999), in which a group of homoeroticized Israeli soldiers arrayed along a table call to mind the final meal Jesus shared with his Apostles before meeting a violent fate.

The strain of co-existence often is most visible along the borders. In Israel, the pressure of living with differences large and small has resulted in the creation of barriers, both physical and symbolic. In her video titled *Sabbath* (2008), Nira Pereg documents the ritual closing of Jerusalem's ultra-Orthodox neighborhoods for a period of twenty-four hours on the eve of the Sabbath, as observant Jews put in place temporary metal fences that block public access. Though officially sanctioned, their presence is a source of ongoing tension, separating Orthodox from secular Jew, as a boundary is drawn between the sacred and the profane. In Boaz Arad and Miki Kratsman's silent, forty-minute video, *Untitled* (2003), the artists consider the impact of another type of fence. Shot at the Erez checkpoint along the Israeli-Gaza Strip barrier, this collaborative work documents a seemingly endless stream of Palestinian laborers returning home after a day's work in Israel. As curator Susan Tumarkin Goodman has observed, "The absence of commentary highlights the men's anonymity, forcing viewers to confront the dehumanizing experience of checkpoints in the lives of Palestinians" and the pain of the occupation in general.[5]

Joseph Dadoune
Ofakim, 2010
Video (color, sound),
14:47 minutes

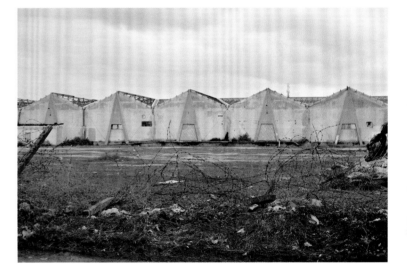

Artist Ori Gersht offers a poetic reflection on contested borders in his video *Neither Black nor White* (2001). Using time-lapse photography to condense eight hours of shooting into a nearly five-minute film, Gersht recorded a fixed view of the Palestinian village of Iksal from a hilltop-site located in the Jewish quarter of Nazareth. As the sun begins to rise, an image that originally appeared to be a pitch-black sky dotted with stars gradually is revealed to be town of Iksal, bathed in a cool blue light. Slowly, the Mediterranean sun begins to brighten, engulfing this quiet landscape in an intense white light that virtually obliterates the scene, as the cycle repeats. As the title of this work sensitively underscores, the political and moral complexity of territorial conflict cannot simply be reduced to black and white.[6]

The immigration of Jews from the diaspora to Israel is one of the basic principles of Zionist ideology, with more than three million people arriving from ninety countries since 1948. And while making Aliyah is the highest aspiration for some, the experience has proved to be quite

challenging for others. In his video titled *Ofakim* (2010), Joseph Dadoune focuses on the desert development town in Israel's southern periphery that he calls home. Ofakim is one of several working-class towns that were built in Israel during the 1950s to house the large waves of new immigrants that were arriving mostly from North Africa and India, and which, due to inadequate educational, health, and employment opportunities, became sites of marginality and neglect. The young performers that appear in Dadoune's video, all participants in the larger cultural and social program he founded in Ofakim, are children of the immigrants who once worked in the abandoned textile factory where it was shot. This culturally diverse group of young people stands at attention, as if silently honoring the workshop's past, before hoisting a missile from the factory floor onto their shoulders and marching off into the desert on a communal journey seemingly to nowhere.

The Negev Desert also is home to approximately 110,000 Bedouin Arabs, a traditionally nomadic, conservative minority that is not fully integrated into Israeli society. In August 2010 photographer Miki Kratsman lived with the Bedouin, documenting the forced evacuation and demolition of one of their villages by the Israeli government in a series of black-and-white photographs titled "Displaced." His subjects include the improvised, light structures that were once part of this "unrecognized village" and a collection of portraits taken of the town's former inhabitants. These quiet yet striking images of a people who lack visibility within the larger culture capture their pride and their presence, despite the poverty and desolation they have experienced.

Dor Guez presents a moving video portrait of three generations of a Christian Arab family, whose experience as an ethnic and religious minority within a minority in Israel sheds light on the country's complex relationship with its Palestinian-Israeli citizens. In a video interview titled *July 13* (2008–9), family patriarch Jacob Monayer recalls the day in 1948 when the Israeli army entered his hometown of Lod (southeast of Tel Aviv) and proceeded to occupy the city and expel most of its Palestinian residents, forcing others into hiding. He tells his story with admirable forbearance. His granddaughter, the subject of *(Sa) Mira*, (2008–9) and whose fair appearance and flawless Hebrew prompt some Jewish Israelis to take offense when they learn she is an Arab, recounts her experience of present-day racism with less equanimity. The varied, sometimes contradictory, national, linguistic, ethnic, and religious identities personified by the cosmopolitan Monayer family challenge the strict po-

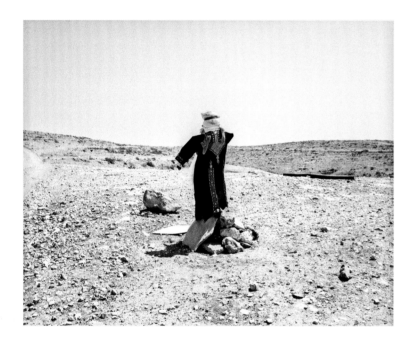

Miki Kratsman
Displaced (10), 2010
Digital pigment print

larities that have defined the politics of the Middle East and suggest more flexible alternatives for Israel's multicultural future.[7]

In 1988 the Israeli novelist David Grossman published a searing account of what he had witnessed in the West Bank in early 1987, deploring the escalating human costs that were felt by both occupier and occupied. Almost fifteen years later, when the book was re-issued, he wrote a new preface, in which he described the situation as being much the same: "So many things have happened since *The Yellow Wind* was published, and so little has changed."[8] In the 2002 edition, he added an afterword, in which he mused about whether he could write the same thing again in the future. And now, in 2013, it seems he might be able to repeat it once more. That 2002 afterword he dedicated to all those "who still believe that peace between the Palestinians and the Israelis is possible."[9] He went on:

> Somewhere in the future we will arrive at the single possible solution that can ensure the lives of both sides. When that happens there will be two independent sovereign states here, side by side, Israel and Palestine. A border will separate them, not an iron wall of continuing hatred and mutual ignorance. A *border* between two neighboring countries.

> At the present moment it is difficult to believe that this can ever happen. . . . Yet despite this, if we don't remind ourselves that a better future is possible we may never find the strength we will all need to get there.[10]

Let us hope they do.

1. Thomas L. Friedman, "Bits, Bytes and Bombs," Sunday Review, *The New York Times*, March 24, 2013, p.13.

2. Ibid.

3. Lilly Wei, "Where History Becomes Art, Israel Report," *Art in America*, January, 2010, p. 55.

4. Lilly Wei, "Israel Report Part 2: The Homeland Within," *Art in America*, March, 2010, p. 75.

5. Susan Tumarkin Goodman, "A Matter of Place," in *Dateline: Israel New Photography and Video Art* (New York: The Jewish Museum; New Haven and London: Yale University Press, 2007), p. 30.

6. Al Miner, "Ori Gersht: History Repeating," in *Ori Gersht: History Repeating* (Boston: MFA Publications, 2013). I am grateful to Al Miner for his observations on Ori Gersht's *Neither Black nor White*.

7. Gannit Ankori and Dabney Hailey, "Sabir (To Know)," in *Dor Guez: 100 Steps to the Mediterranean* (Waltham, Mass.: Rose Art Museum, 2012). I offer my thanks to the authors for their insights into Dor Guez's video work.

8. David Grossman, afterword to *The Yellow Wind* (New York: Picador/Farrar, Strauss and Giroux, 2002), p. 217.

9. Ibid., pp. 221–22.

10. Ibid.

ON ART AND POLITICS IN ISRAEL

FOLLOWING *THE COMPROMISED LAND*

ORY DESSAU

Ory Dessau is a curator and writer based in Berlin and Tel Aviv. In 2011 he curated The Second Strike *for the Third Herzliya Biennial of Contemporary Art.*

"Israel is not a country. It is not even, as someone has suggested, a state of mind. It is simply a disorderly, systematic collection of paradoxes that somehow seem to make sense, don't ask me to explain why. Whatever you may say about Israel or Israelis, the opposite is equally true: every man, woman, and child here seems to be mobilized for war, yet, every time they want to say *hello*, *goodbye*, *how's your grandmother*, or *what's up*, they say *shalom*, which means peace, and in a crazy way they make you believe they mean it. There is no aristocracy of rank or wealth, not even a sense of rank in their army--not because they are so democratic, but because everyone here thinks he's a general. And the greatest paradox of all is that I, Roy Hemmings, have got myself stuck here, to report on a war that will not take place."[1]

Above is Uri Zohar's opening speech from *Every Bastard a King* (1968). The film focuses on Israel and Jordan in the days before the Six-Day War, a time that is often referred to as "the waiting period." The speech is brought by an American journalist named Roy Hemmings (played by William Berger), who arrives at this piece of land to cover the days of the waiting period, days of anxiety and anticipation for an apocalyptic war. *Every Bastard a King* was filmed soon after the actual war and was part of the national euphoria that swept Israel after her swift victory, but it did not avoid criticism of the militancy and fanaticism of Israeli society at the time. The Israeli guide who escorts Hemmings is filled with joy when receiving his mobilization order at the end of the waiting period and anti-war demonstrations are presented in the film as meaningless. The only person in this film who resists the war with all his might is Hemmings himself, the only main character that eventually dies (after the war is over), by accidentally stepping into a mine field (not a heroic death). What can we learn from all of this? That the Israeli culture, even when it participates in the idealized self-image of the state of Israel, cannot avoid attributing blame and exposing the paradoxes this world picture is held by.

This text is an associative sequence of elaborate comments, following the exhibition *The Compromised Land: Recent Photography and Video from Israel*. These comments relate to one another, while aspiring to be independent and detached, so as to reflect the lack of opportunity to reveal one formative story in context of Israeli art and culture, and maybe even of Israel itself as a coherent entity. The national Jewish project is, on the one hand, a project deriving its inspiration from an ethos of progressiveness and profanation, while on the other hand, the project requires the Jewish religion to justify and validate itself. It is the result of a strange integration between the necessary distancing from the Jewish religion and the assimilation of the religion as the basis of establishing the "Jewish State." Therefore, the Israeli culture moves between an abundance of structured paradoxes. It is situated in a constant struggle, both internal and external, regarding its own historical and ideological background, and cannot rely on a distinct canon, a unifying super-narrative which can be fought and disassembled, in an artistic avant-garde framework. In many aspects, this culture never consolidated, and in rela-

--

tion to the history of modern and contemporary art, it has a "weak context," as characterized by artist Zvi Goldstein. In a discussion about the concept of the "peripheral" in his oeuvre, Goldstein defines Israel as a culture which arrived into modernity and modernism "neither through consecutive evolution, as in Europe or the United States, nor through an accumulation of geological strata of knowledge and experience and a historical stock of common events--strata of cultural referents, partially non-verbal, that together make up what I call a 'strong context.' Donald Judd's reductivism would not have been possible without strong context, a Joseph Kosuth text could not exist as art without strong context. Only a strong context can provide backing to a disruption of the linguistic and symbolic order."[2]

The Compromised Land is a combination of different discourses. It shows us a constellation of in-depth views, revealing the cracks in images we call Israel--society, space, and culture, with an unresolved identity found in a violent conflict. This violent conflict between the Jewish-Israeli society and the Arabic-Palestinian society in the geographical unit situated between the Mediterranean Sea and the Jordan River, and between the Jewish-national entity and the Arab states surrounding it, has been going on since the establishment of the state of Israel in 1948, or to be exact, with the decision of the United Nations General Assembly to end the British Mandate in November 1947. It in fact started with the migration of the first Zionist immigrants at the end of the 19th century, which quickly resulted in a disagreement between them and the Arab residents of the country. It is therefore regarded as an ongoing war stretching over more than a century, a war which has known, and sadly may very well continue to know, very violent peaks. Nonetheless, a synoptic view of this era can also reveal that it is a war of low intensity, in most part, and maybe both sides of the conflict are not as blood-thirsty as they tend to define one another, and an optimistic horizon of a mutual and constant desire for peace is possible. The example I often use is the civil war in Rwanda (1994), in which more than one hundred thousand people were murdered in ten days of fighting (it is assumed that approximately one million citizens were killed during the one hundred days of war). If we look at the Israeli-Palestinian conflict as some sort of civil war and compare the two wars (a reasonable comparison because Rwanda and Israel share colonial history, and war in Rwanda was between two different groups similarly close to each other), we see that during more than a hundred years of collision, less than a hundred thousand people in total died on both sides. Yet, the protracted, low-intensity nature of the war is not just an encouraging sign of contained and controlled "non-lethal" violence; in effect it also promotes detachment and neutralizes the ambition of ending the war and changing reality. Maybe this is also why the Jewish-Israeli society and culture are somehow indifferent to the lack of solidarity and justice that accompany this ongoing war, which many Israeli artists show no interest to depict explicitly, preferring distant, uninvolved views of the space in which the conflict takes place and the sectors and classes it has been producing throughout the years.

--

The works of Nira Pereg and Barry Frydlender featured in *The Compromised Land* illustrate this kind of alienation. Pereg and Frydlender, each in their own way, refer to their applied means of representation while distancing themselves. They are not concerned with personal judgment or intervention but with the implications of the encounter between an impersonal photographic technology and the photographed subject matter, whether it's the armed forces guarding Pope Benedict's visit to Nazareth (like Frydlender's 2011 work, *The Visit*), or the orthodox Jews secluded in Jerusalem (like Pereg's 2008 work *Sabbath*). In their works, Frydlender and Pereg reduce the subjective dimension of representation and underline the mechanisms for visualization that their opaque depictions rely upon. Frydlender does this by emphasizing the digital construction of his composed images and Pereg by emphasizing the montage cuts in some of her video works. Both express the connection between programmed visualization and programmed social behavior and power systems.

A similar approach, linking an impersonal, technologized representation of the local landscape and its political status, is taken in Nir Evron's *A Free Moment* (2011). Evron is represented in *The Compromised Land* with an earlier work (*In Virgin Land*, from 2006), yet the one I refer to signifies his artistic approach in general. *A Free Moment* features a movie camera's traveling shot along a track, as it revolves 360 degrees inside the frame of an unfinished building. The structure itself was once intended to be the summer palace of Jordan's King Hussein. Its construction was begun before the Six-Day War in a territory that was then under Jordanian control and afterwards was halted with the outbreak of hostility and Israel's occupation of the area. Evron made the movie without the help of a cameraman, using a robotic camera whose movement was preprogrammed and the duration of whose activity was determined by the length of the film. The movie reconstructs an interim space, detached from the ideological conditionings that would mark it in the framework of the Israeli-Palestinian conflict. The fact that the camera is not manned by anyone points to a spatiality and territoriality which for the time being we are unable to inhabit.

The Compromised Land turns its glance to the cracks of life in Israel. In the exhibition's declaration of intent made by curators Helaine Posner and Lilly Wei, an attempt is made to look at Israel through "eyes that are invested both intellectually and emotionally" by artists born and raised in this country, who present in their works many aspects of the social-historical space, as well as of the natural-physical space that the country produces. Posner and Wei dem-

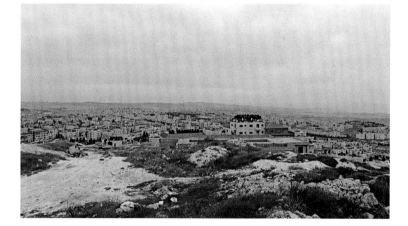

Nir Evron
A Free Moment, 2011,
Still image from 35mm B/W film converted to HDCam Video,
04:00 min.

onstrate these aspects, not by instrumentalizing the works in the exhibition into a simple historic illustration. For them, these works not only are carriers of signs, but they have the ability to conduct concrete situations in space. The curators do not subordinate the art, forcing it to tell a national hegemonic story in a way that undermines the independent value the works display. They also avoid telling a comprehensive story about Israeli art, as goes Ernst Gombrich's famous line "there really is no such thing as art, there are only artists," meaning, there is no general transcendental definition of art in isolation from the reference to bodies of works by specific artists. It goes without saying that the curators do not take a formalist attitude insisting on autonomic art. The bond between the aesthetic and the historical in this exhibition can be defined as symptomatic. Art is not describing a historical situation; it is the outcome of historical conditions, giving rise to new means of representations and unique artistic attitudes, which can both give testimony about the world from which they arise, without being its simple illustration or external description.

(left)
Sharon Ya'ari
Central Bus Station Back, 2007
Archival pigment print
53 ½ x 44 ⅞ inches

(right)
Sharon Ya'ari
Central Bus Station Front, 2007
Archival pigment print
53 ½ x 44 ⅞ inches

I think about the early works of Sharon Ya'ari, whose works are represented in this exhibition. Ya'ari is "the poster child" of new Israeli photography of the mid-90s, continuing throughout the first decade of the 21st century. The gaze he applies to his work distinguishes Ya'ari from other Israeli photographers who preceded him. Take Micha Bar-Am, for example, whose adventurous work evinces a prolonged interest in one-time situations of "decisive moments" from Israeli history. His photographic practice follows in parallel the tremendous momentum of development and the social tensions that characterized Israel in its first decades.

Ya'ari, in contrast, starts from a setting that has undergone a process of banalization. He finds what he is looking for in featureless places, worn and mostly abandoned, where nothing happens. Ya'ari is drawn to fatigued, obsolete sites, and insists on "arriving when the orgy's over," after the social act has already occurred. Nonetheless, in his case, it is hard to talk about testimony in the usual sense. Ya'ari's work relies on the degeneration of a near past, on neglected sites of social activity in the public domain, but it is not reportage. He is not a photographer of social critique; he uses entropic situations, sites, or worn down corners with defected functionality, to gain something different than he presents. The lack of interest he shows in the places he presents, whether it is a quiet corner in a wedding venue or a building's backyard in Tel Aviv, directs the attention back to Ya'ari himself, to his stance against these sights and to his own ability, maybe even his virtuosity, to turn them into intensive, quivering surfaces. Ya'ari's work moves from the acci-

dental to the concrete, from the contingent to the necessary, while each opposite pole derives its power from the other. In many of his works he demonstrates how he takes a meaningless, undifferentiated sight and intensifies it into a severe pictorial activity. Suddenly--and this suddenness is critical--the image becomes spectacular. Ya'ari shows us how a worn-out, deteriorated place becomes a meaningful expression. The borderline in his work fills a crucial part: the elements present the possibility of becoming a passing image. The richness derived from this situation stands in inverse relationship with the meagerness of the vision. After we have characterized Ya'ari's aesthetical approach, we can take what it has to tell us about the social-historical situation from which it derives, in which a landscape turns into a wasteland, utopia into melancholy, and a mapped territory becomes a "middle sector."[3]

In a lecture given during the peace process by writer and poet Yitzhak Laor, at some point between 1993—99, he spoke about the lack of a Hebrew equivalent for the English word *country*. Hebrew, wherefrom stems the Jewish and Israeli psyche, shifts from *state* to *land*. It lacks a dimension that marks daily civil and private life, where one can let ideology or mythology lie and enjoy an agreed-upon shared space. It is able to identify the administrative authority or the physical place it tends to mystify, but nothing in between. An extreme example of mystified attachment to physical land that, in the context suggested by *The Compromised Land*, can be read as an exaggerated expression of Jewish-Zionist relation to the land of Israel, is found in Gilad Ratman's video *The Boggy Man* (2008). Yet, the work's physical land is not of solid ground but of mud, and it is located somewhere in North America. *The Boggy Man* shows a man staging his slow drowning in a swamp while he holds a video camera. He records his staged sinking and accompanies it with fake screaming for help. *The Boggy Man,* as described by Tal Sterngast, "conducts an autarkic being, relaying merely upon an imagined gaze. He gives in to the mud and unifies with the swamp. His whole body becomes an erotogenic organ that longs to return to the womb."[4]

Unlike Ratman's *The Boggy Man*, Sigalit Landau's video performance *Barbed Hula* (2000), was realized in Israel, turning its own auto-eroticism into an allegorical image which deals with the ways landscape, political territory, historical memory, and mechanical representation leave their violent imprints on the living flesh of the individual subject. In *Barbed Hula* we see the artist's naked torso against the backdrop of the Mediterranean Sea, at dawn. She stands with her back to the sea, spinning a hoop around her waist made from piercing barbed wire. She raises her arms and shakes her pelvis round, while the hoop wounds her repeatedly. From an implement of control used to prevent passage and access, it becomes a self-bruising gadget. Despite the continuous injury, the dance moves go on: the hoop continues to move around her pelvis and does not fall. Retaining the principle of the game takes its toll on her body, and instead of ensuring pleasure, it assists in an act of self-mutilation. Landau's

dancing-playing body operates as an apparatus for production of pain and passion, passion for pain; she situates herself beyond the pleasure principle, within a loop of torture and revival, amusement and self-abuse, sustainability and vulnerability, loss of sensation and its enhancement.

The private body, and specifically the female body, is defined via this act (as in other works by Landau) as an arena of struggle between internal and external forces. The body functions as a surface for adding and subtracting signs and substances. Leaving the head outside the frame condemns the body to anonymity, and yet the woman's act is typified by bizarre circus-like acrobatic exhibitionism--an acrobatic show of bodily domestication. Through repetition of the rotary act, the body comes close to the mechanical, while being exposed in its humanness. Landau adapts herself to a technological logic external to her: the rotation sequence of the twirling hoop corresponds with the sequence of frames per second, which, in turn, corresponds with the sequence's editing. The obsessive clinging to a gesture (cyclical motion) or an object reflects the technological logic which documents and at the same time deconstructs this very adherence.

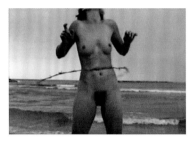
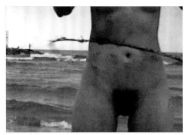

Sigalit Landau
Barbed Hula, 2000,
Video (color),
1:52 minutes

The repetitious, cyclical gesture unfolds in a disconcerting spectacle, disagreeable to the eye. It sweeps in the viewer, who breaks free from the grip of the moving image only when he discovers the montage manipulation (slow and fast motion, loop screening that fabricates duration). The violent gesture of the dance prevents any possibility of a distant, uncommitted gaze--while revelation of the elusive montage distances the viewer, allowing him or her analytical scrutiny of the conditions underlying the performance, which are observed from the outside. In this work, Landau moves from representation of violence to the violence of representation: leaving the woman's head outside the frame in the violent act of framing indicates the violence taking place inside the frame and its status as an internal and external boundary. The body's wounding by the frame (the cropped head) corresponds to the wounding within the frame (the wounded abdomen). The body is drawn to the perimeter of the hoop, leaving its center empty. Its centrifugal motion around an invisible axis deconstructs it, rendering it a living example of fission, lack of fixedness, penetrability.

Rather than a material, the barbed wire is a means, a function, and a sanction. Landau activates the means as a sanction. This activation calls to mind a set of other applications: the barbed

wire hoop also refers to a modern military reality--historical as well as current, ongoing and transient, periodical and unique, banal and anomalous. In view of the link between the hoop and the isolating barbed wire fence of the camp, the pen, the quarantine, one may also define the hula-hoop dance, with its childish girlish aspects, as an expression of traumatic recollection, as an attempt to confront a memory that can neither be vocalized nor silenced (but only revisited, to be caught therein). The past is not presented as a closed chapter, an object to overcome, but rather as an ongoing sequence of interruptions and mending which leaves its imprint on the living flesh. There is no unrolling here, only tearing: time tied together through wounds.

The hula-hoop video performance blends allegory and phenomenology, purpose with purpose-lessness. It unfolds a multiplicity of implications concerning the historical present, just as it functions as a temporary site of conversion: the barbed-wire hoop is also the circle of stars in the European Union emblem, and at the same time, it may be perceived as a crown of thorns; Landau's body channels the suppressed historical and psychological associations her site of action carries within. Her masochistic auto-erotic act transforms itself into optical illusion, which turns out to be a self-sacrifice.

The images that comprise *The Compromised Land* cannot be summarized as pure depictions of the Israeli condition. The exhibition unfolds an open reflective space in which one can criti-cally examine the implications of representing the Israeli landscape through the spatial per-ceptions, ideologies, and historical narratives each artist's worldview inevitably promotes. All this creates many Israels, a multitude resulting from the fact that the featured Israeli artists endeavor to generate their own discourse of Israel, avoiding the reproduction of the official public discourse while at the same time offering more than a simple refutation. In other words, *The Compromised Land*'s featured artists do not apply a rhetoric of explicit resistance, which can only reaffirm existence as that which is being rejected. In this way the artists offer some-thing more than commentary--a complex vision, both factual and imagined, of what Israel has been, what it might be, and what it is.

1. *Every Bastard a King*, directed by Uri Zohar, Israel, 1968.

2. Ory Dessau, "To Be There: An Interview with Zvi Goldstein," *Studio Art Magazine* (Tel Aviv), no. 174 (September 2008): p. 40.

3. Efrat Shalem, "Speaking with Sharon Ya'ari," *Studio Art Magazine* (Tel Aviv), no. 118 (September 2000): p. 22.

4. Tal Sterngast, "Gilad Ratman," in *The Second Strike*, ed. Ory Dessau (exh. cat.) (Herzliya, Israel: Herzliya Museum of Contemporary Art, 2011), p. 85.

TWO STATES FOR TWO PEOPLE

DR. RON PUNDAK

Dr. Ron Pundak is an Israeli historian. He was one of the architects and negotiators of the Oslo Agreement and serves as chairman of the Israeli Peace NGO Forum.

My grandfather fled Ukraine in 1905, after a pogrom in his city in which many Jews had been killed. My father escaped Denmark and became a refugee when the Nazis began to round up Jews in October 1943, in order to send them to the gas chambers. He fought for the establishment of Israel in 1948. My brother, who was born in Denmark, was killed as a young IDF officer in the Yom Kippur War in 1973, one of six wars that Israel has fought since its inception. And I--trying to change the course of the Jewish-Israeli history of escape, refugeehood, war and death--was one of two Israelis who initiated the Oslo Channel, and part of the small and secret team that reached an agreement with the Palestinians. It is an agreement which should lead to peace, and start the last part of the journey to end the Arab-Israeli conflict, and establish a normal state which will stop being pursued by its fears.

The basic principle leading to the establishment of Israel was the need, at the end of the 19th century, to establish a national homeland for the Jews in the Land of Israel. Jews were persecuted in Europe, anti-Semitism erupted almost everywhere, France accused of treason an officer named Dreyfus just for being a Jew, and the cry of the French liberal Émile Zola, *J'accuse* (I accuse), stayed hung in the air. In Vienna, a young intellectual named Herzl began to weave a dream. The unfortunate climax was reached before and during World War II--the Holocaust. Six million Jews were killed only because they belonged to a particular group defined by the other as Jews. These are the memories and history, or what has sometimes been called the "collective DNA," that Israelis have been carrying since the state was born.

In 1882 practical Zionism brought the first group of Jews to the Land of Israel in order to build a state which would serve as a safe haven for Jews, wherever they might have been. Herzl, who wrote in his book *Altneuland* a vision for this future state, dreamt about a new society which was to adopt the European culture, to overcome class and religious tensions, to establish a secular and egalitarian society and a welfare state, to create room for private initiative, and to maintain full equality for the local Arab residents. Needless to say that we are not there yet.

But the people without a land, who arrived in Palestine with the thought that they had reached a land without a people, soon discovered that this land--for which they wished and prayed during 2,000 years of exile--was populated with some half a million Arabs who considered this land to be theirs. In the 1930s this group of Arabs went through a process of self-determination and started to consider themselves as Palestinian Arabs, and as a population with a territorial belonging. The reality on the ground turned into a zero sum game: in the Arab view there was no room in Palestine for a Jewish state, and vice versa: in the Jewish view there was no room in the Land of Israel for a Palestinian state.

On May 15, 1948 the state of Israel was declared and the Israeli-Arab struggle, which had already started years earlier, transformed into a war of "to be or not to be." This war ended with two far-reaching results: a very impressive Israeli military victory against seven Arab armies, in which Israel increased its territory more than fifty percent, and at the same time, half of the Palestinian

population--some 650,000 people--became refugees. This is the moment in which the two contradicting narratives begin to take shape: the establishment of Israel as a national home for the Jews, against the Palestinian *al-Nakba* (catastrophe). Simultaneously, the fight for the mindset started to take place, and extremism, hatred, and exclusion became the dominant discourse. This is also the moment when Israeli art makes its first serious steps as a mobilized tool in the name of the Zionist narrative, serving the Israeli establishment and public consensus. Only many years later, specifically during the 1970s, would Israeli artists sober up and start to be more critical--through their work--of the prevailing narrative, which had managed to erase the Palestinians who fled or were expelled, and to wipe out their legitimacy as a people with national aspirations.

Since its establishment, Israel has become a society in rifts and cleavages. But the Israelis refuse to give up: war, occupation, tension, fear, and paranoia live side by side with vision, economic and industrial development, a state-of-the-art healthcare system, high-tech entrepreneurship, science, R & D, and cultural achievements. The average Israeli is tired of wars and ideology, and all polls over the last decade unequivocally show that an overwhelming majority is ready to give up the "territories" in return for a two-state solution and normal life, as long as their security will be safeguarded.

The format in which to reach a normal Israel--one which will remind us of what our founding fathers intended--is a peace agreement with the Arab world. Such a regional agreement is still possible following the Arab League Peace Initiative of 2002, which offers full normalization of relations between Israel and all twenty-two Arab countries. The precondition for this is a peace agreement between Israel and the Palestinians, based on Israeli withdrawal from the territories occupied in 1967, while also taking into account the reality that has since been created on the ground. The process we started in Oslo in 1993 was to be the first major step to take us from an era of conflict to an era of reconciliation and co-existence. This agreement was built upon two pillars: the first is the mutual recognition between two national movements which had fought each other and now recognize the political legitimacy and self-determination of the other. The second refers to the modality of the solution and implementation of the agreement in accordance with the objectives of UN Security Council Resolution 242 and its proposed formula of territories for peace.

The Oslo agreement was not a peace agreement but only a declaration of principles which should lead the sides to an interim agreement and negotiations leading toward the permanent status of two states living in peace alongside the other. Oslo, the peace process, and peace itself, are all intermediate stations. The real objective for Israel is to complete the process of its creation and start living normal life without fear. The main question is whether we have the right leadership to take us to this destination.

If the two-state solution dies, Israel will only be left with ugly options. The wish to sustain the status quo is unattainable, as is the policy of managing the conflict rather than making an effort to resolve it. The option of unilateral withdrawal to the line of the barrier is not only far-fetched

but would also incur most of the costs of a two-state solution with only few of the benefits. Israel can force an annexation of some fifty percent of the West Bank and inform the Palestinians that they may declare the rest as their state, but this will never be accepted by either the Palestinians or the majority of the world. There are Israelis who suggest annexing the West Bank and giving all Palestinians Israeli citizenship, making Israel a bi-national state, which would soon have Arab majority. There are others who support annexation without giving Palestinians citizenship--embracing apartheid. Be that as it may, the truth of the matter is that there are really only two realistic options: a clear-cut two-state solution that follows the line which started in Oslo, allowing Israel to begin releasing itself from the paranoia and the demons of the past, or being pushed by Israeli hardliners toward different avenues leading us to reoccupation of the West Bank and Gaza Strip, and deterioration of our relations with the other Arab countries, including those like Egypt and Jordan who have peace agreements with Israel.

This is the historic fork in which we have stood for the past twenty years, since Oslo. Selecting the appropriate turn will strengthen the values of liberalism, will end the occupation, and will create readiness for partnership and co-existence with the Arab citizens of Israel. It will also influence internal attitudes, including compassion for the weak, equality, social justice, and the cessation of preferential policies in favor of the settlers who live essentially outside future borders of the state. Choosing the wrong turn will lead us to perpetuate the occupation and will push us into a more violent struggle between Israel and the Arab world and even beyond. We need to view the long, arduous peace process as a runner would view a long, arduous marathon: both are challenging and crisis-prone yet achievable, and their ultimate goals are clear to everyone. The public on both sides wants peace, and we need to believe that the peace process will ultimately lead to an Israeli-Arab peace.

Peace is a choice in an enlightened Israel: a country which deals with inclusion rather than exclusion; a forward looking and progressive society rather than a reactionary and fundamentalist one; a state which strengthens its minority rather than looking at them as a fifth column. The peace process is a journey toward normalcy, as Prime Minister Rabin stated at the signing of the Oslo agreement on the South Lawn of the White House: "We, like you, are people who want to build a home, to plant a tree, to love, to live side by side with you in dignity, in empathy, as human beings, as free men. We are today giving peace a chance, and saying again to you: Enough. Let us pray that a day will come when we all will say: Farewell to the arms. We wish to open a new chapter in the sad book of our lives together, a chapter of mutual recognition, of good neighborliness, of mutual respect, of understanding."[1]

1. Prime Minister Yitzhak Rabin, address made during the signing of the Israeli-Palestinian Declaration of Principles, Washington, DC, September 13, 1993.

PLATES

Boaz Arad
Kings of Israel, 2009
Video (color, sound), 9:30 minutes

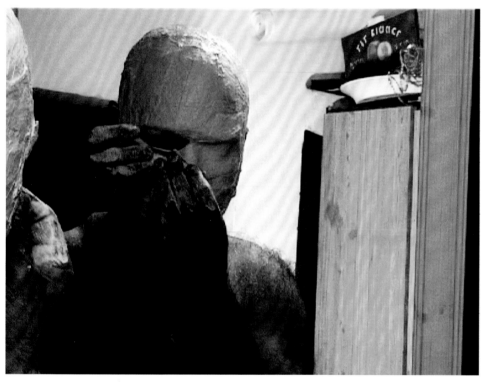
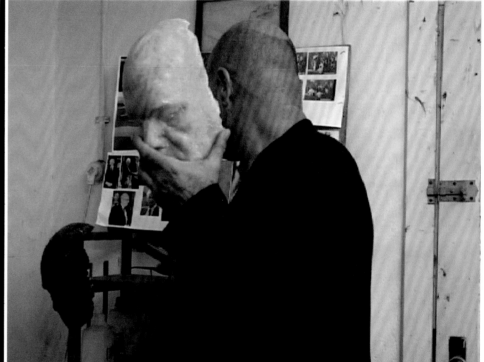

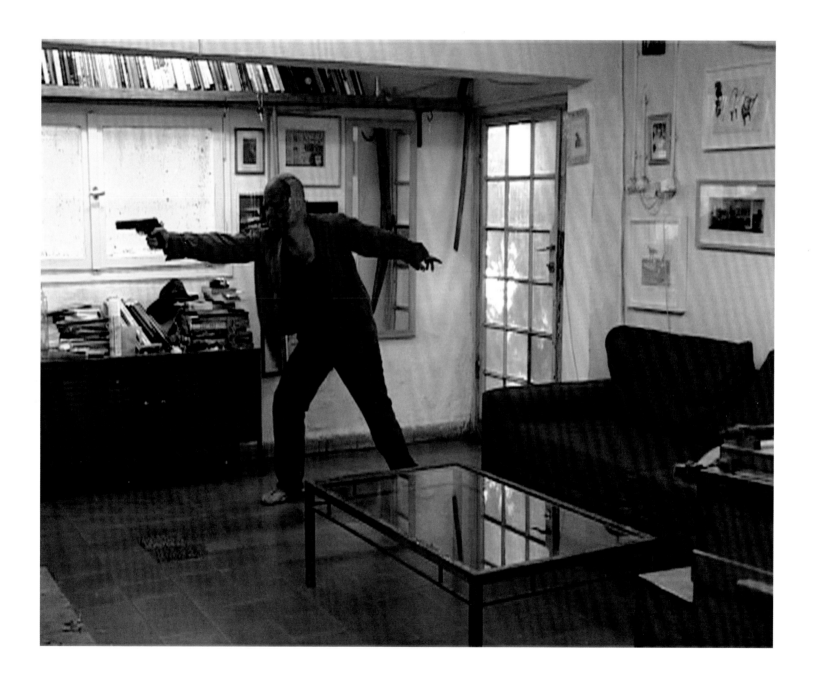

Boaz Arad and Miki Kratsman
Untitled, 2003
Video (color), 40 minutes

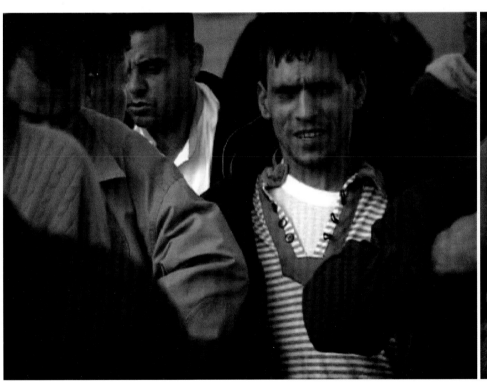

Yael Bartana
Trembling Time, 2001
Video (color, sound), 6:20 minutes

Yael Bartana
Mary Koszmary (Nightmares), 2007
16mm film transferred to video
(color, sound), 10:50 minutes

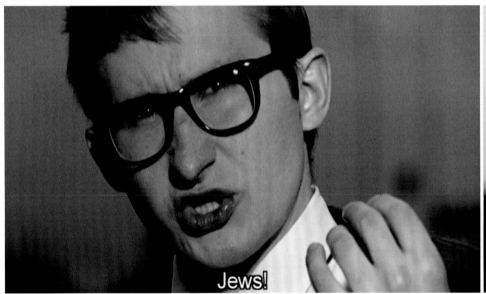
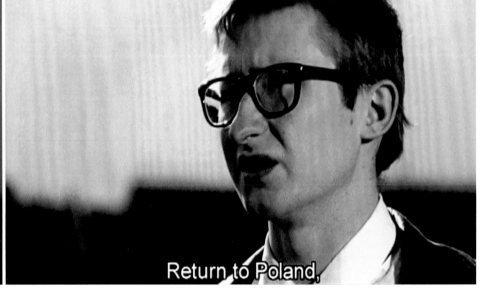

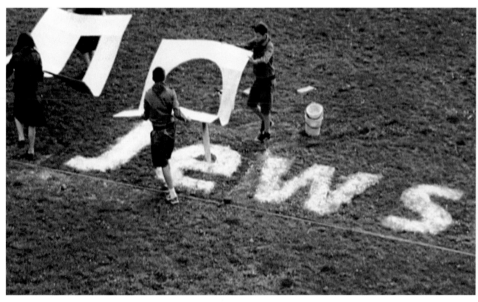 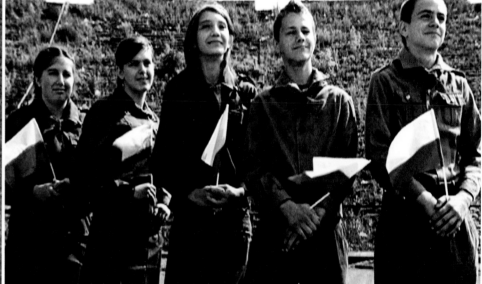

Joseph Dadoune
Ofakim, 2010
Video (color, sound), 14:47 minutes

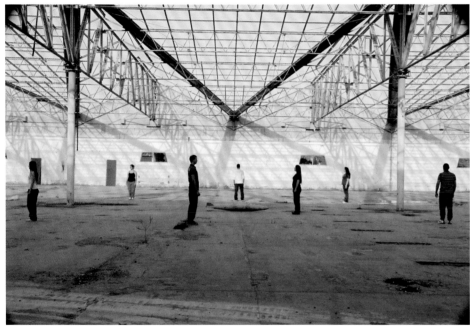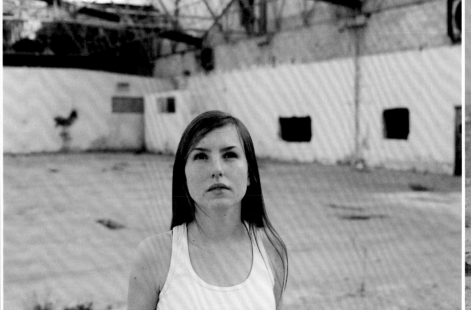

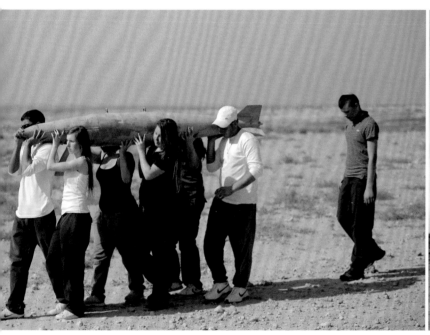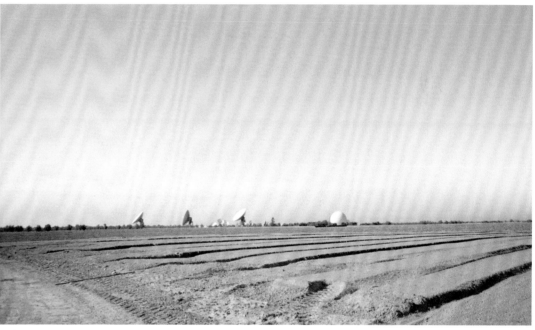

Nir Evron
In Virgin Land, 2006
Video (black-and-white, sound),
12 minutes

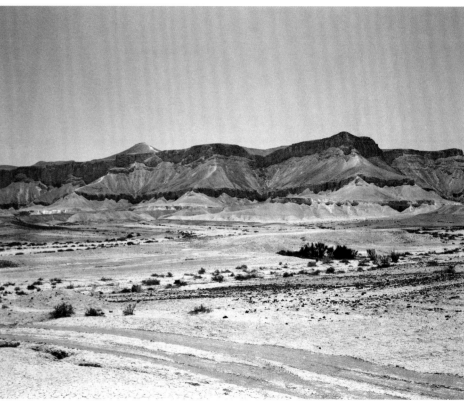

Barry Frydlender
The Visit (Nazareth), 2011
Chromogenic color print

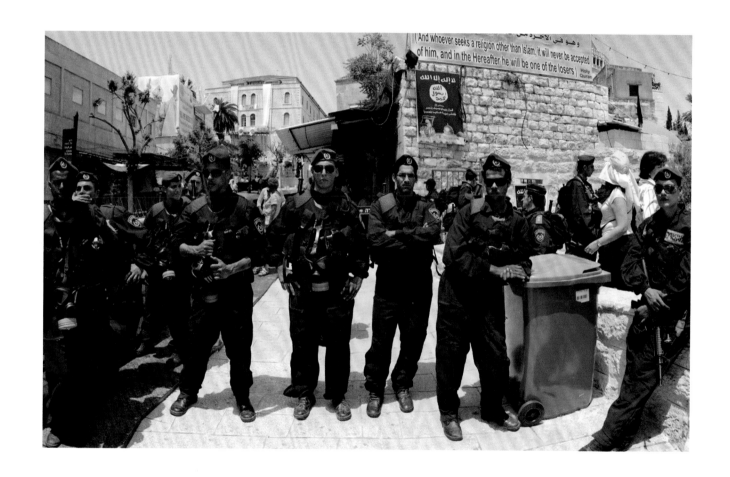

Barry Frydlender
Shirat Hayam
("End of Occupation?" Series #2), 2005
Chromogenic color print

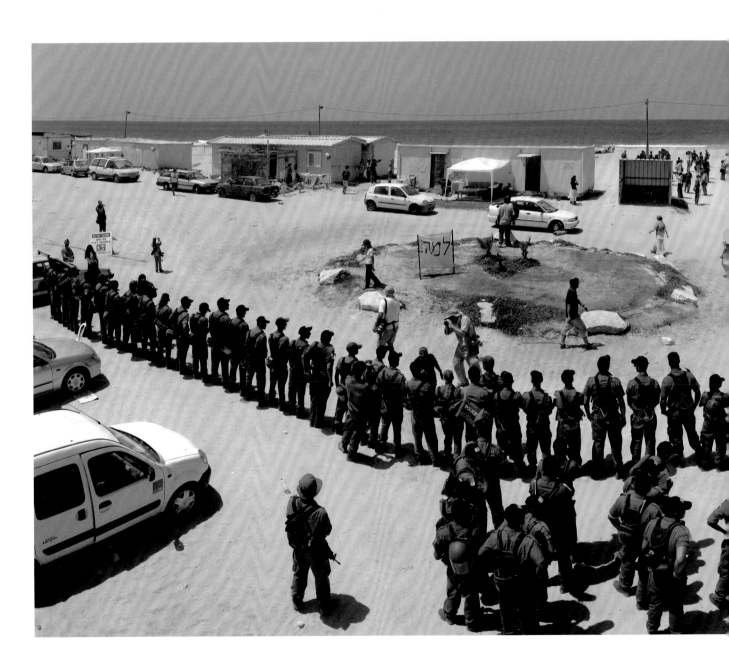

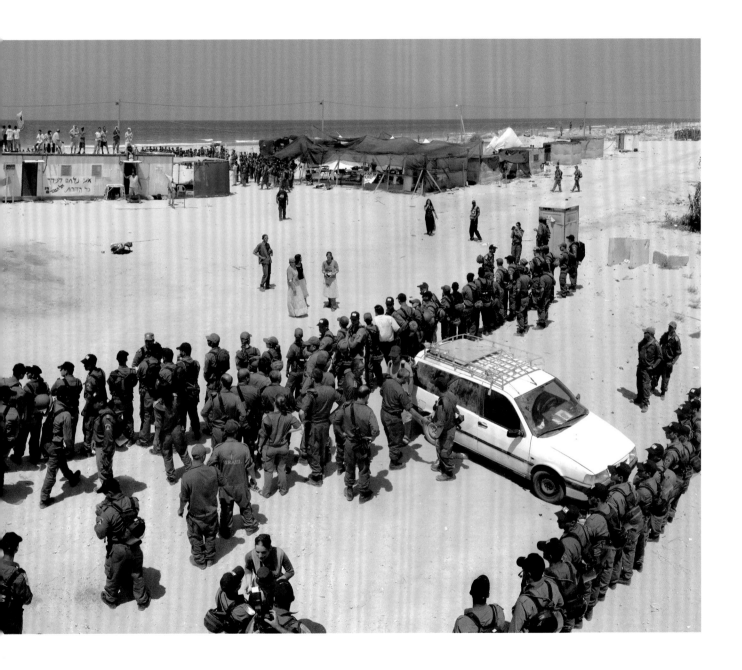

Dani Gal
Nacht und Nebel (Night and Fog), 2011
Video (color, sound), 22 minutes

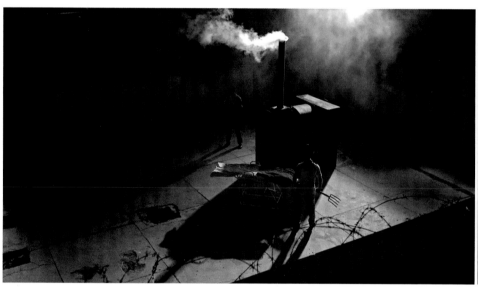
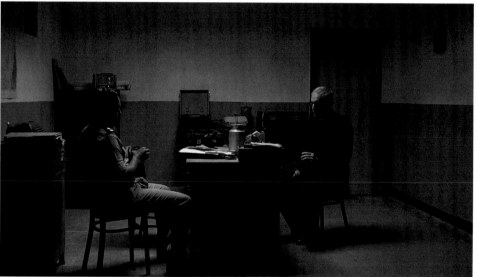

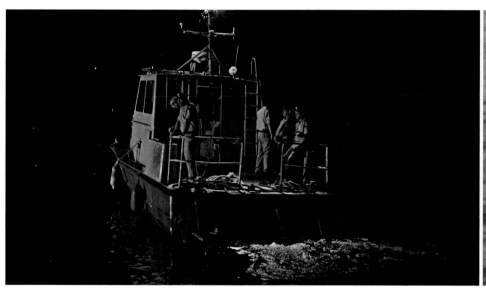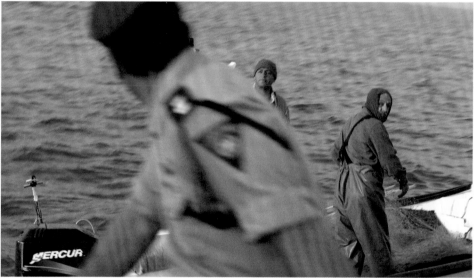

Ori Gersht
Neither Black nor White, 2001
Video (color, sound), 4:45 minutes

Ori Gersht
Pomegranate, 2006, produced 2007
Digital video (color, sound),
3:52 minutes

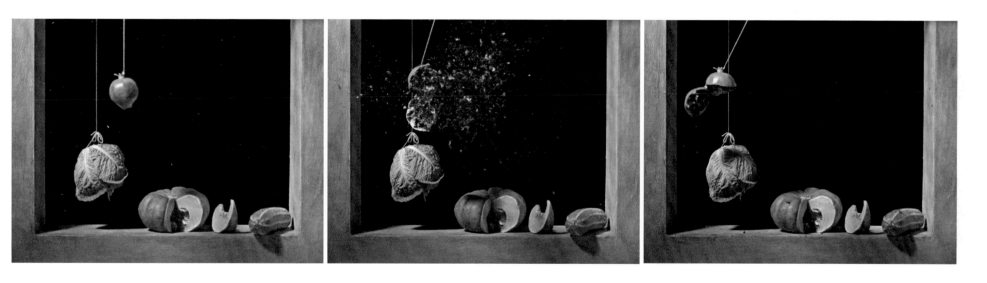

Dor Guez
July 13, 2008–9
Video (color, sound), 13:18 minutes

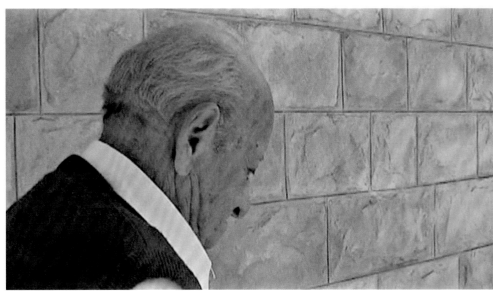
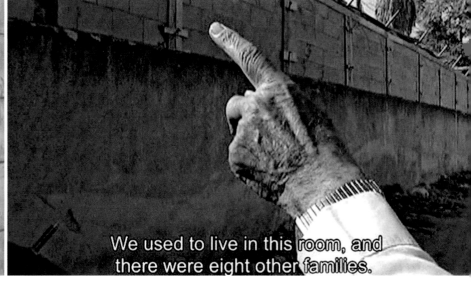

We used to live in this room, and there were eight other families.

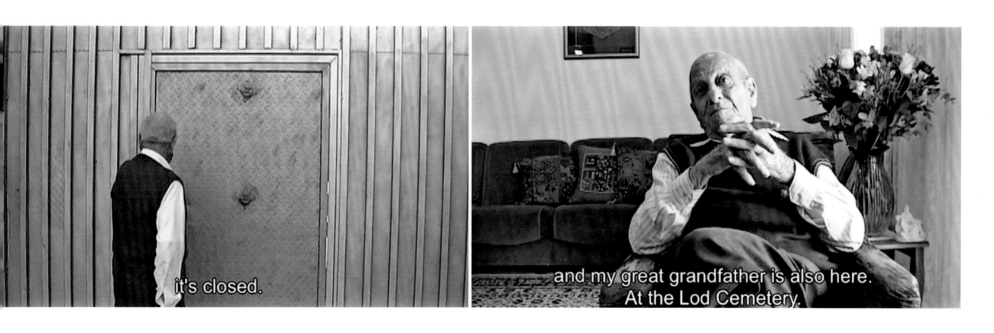

it's closed.

and my great grandfather is also here.
At the Lod Cemetery.

Dor Guez
(Sa)Mira, 2008–9
Video (color, sound), 13:40 minutes

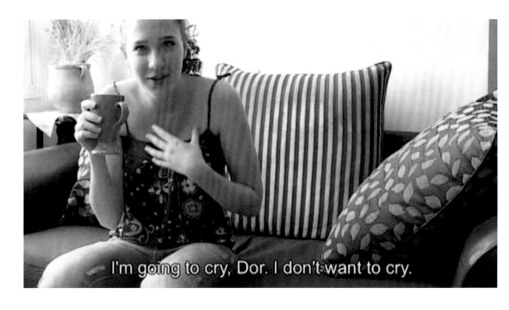

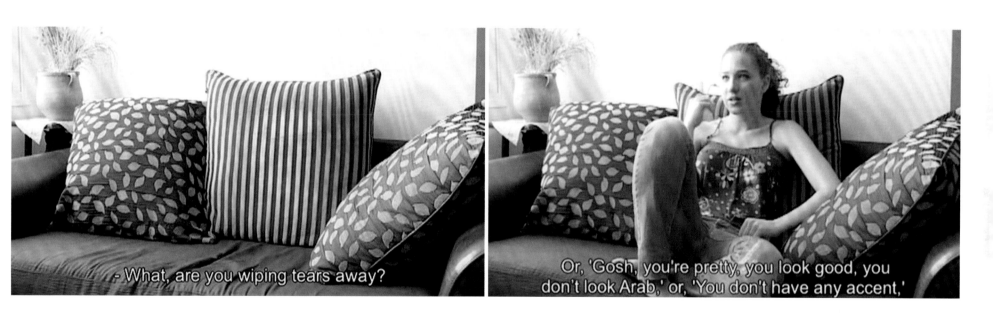

- What, are you wiping tears away?

Or, 'Gosh, you're pretty, you look good, you don't look Arab,' or, 'You don't have any accent,'

Oded Hirsch
Habaita, 2010
Video (color, sound), 2:10
minutes

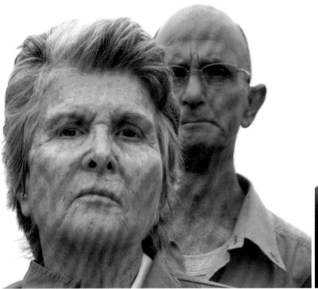
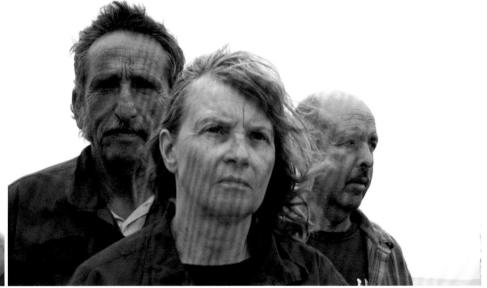

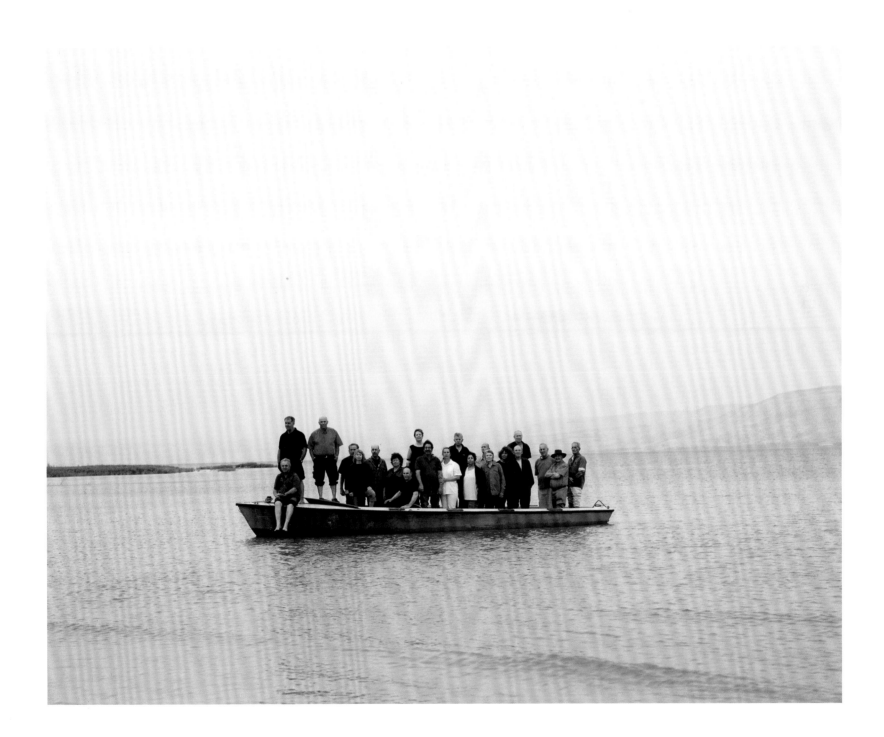

Oded Hirsch
Tochka, 2010
Video (color, sound), 13:20 minutes

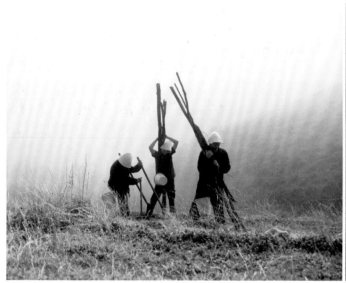 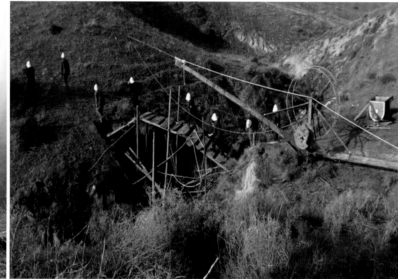 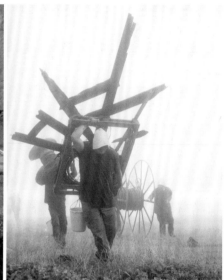

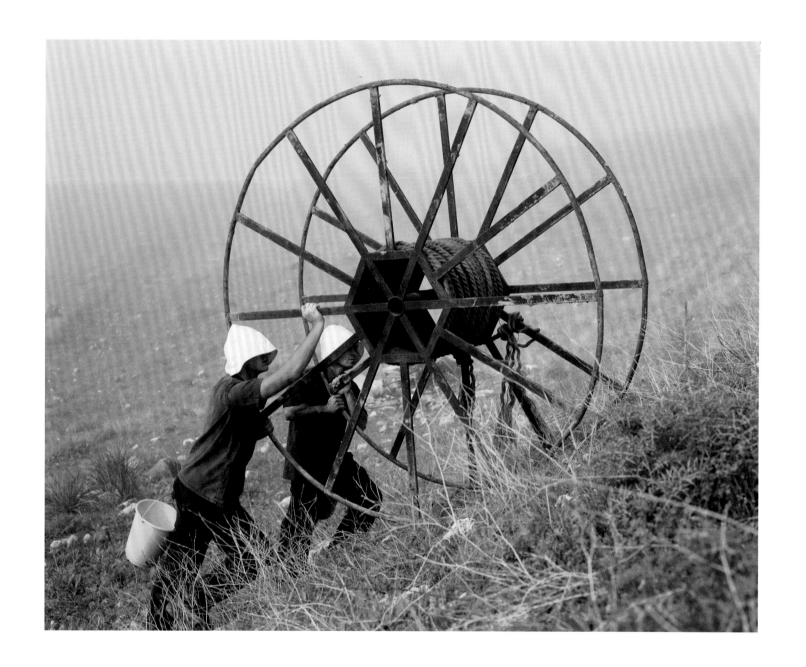

Miki Kratsman
Displaced (5), 2010
Digital pigment print

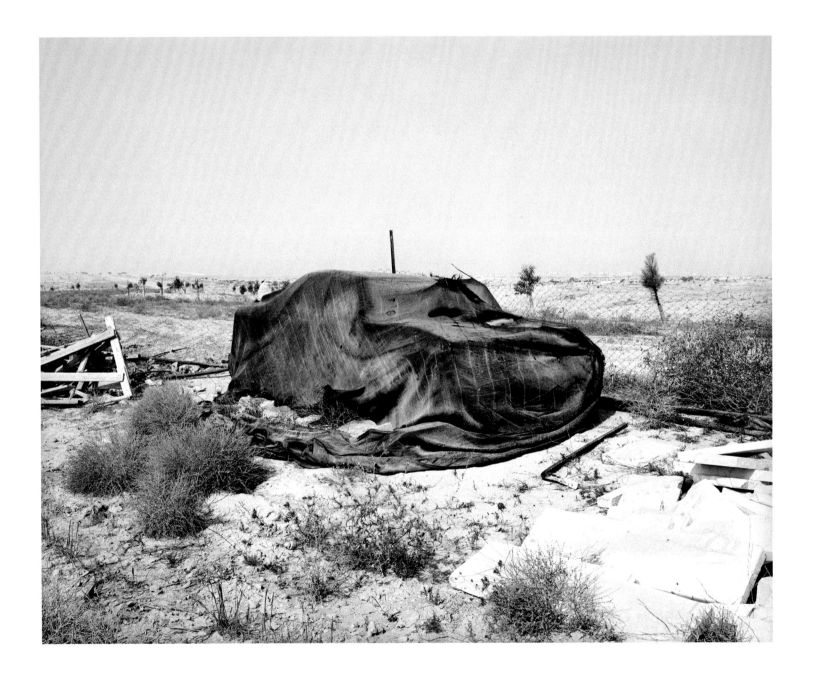

Miki Kratsman
Displaced (7), 2010
Digital pigment print

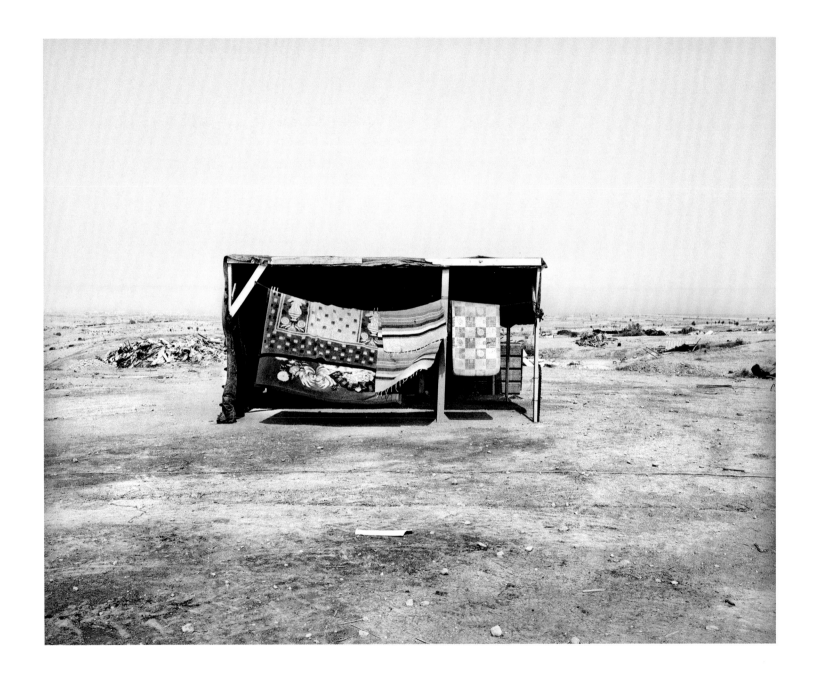

Miki Kratsman
Displaced (11), 2010
Digital pigment print

Miki Kratsman
Displaced (12), 2010
Digital pigment print

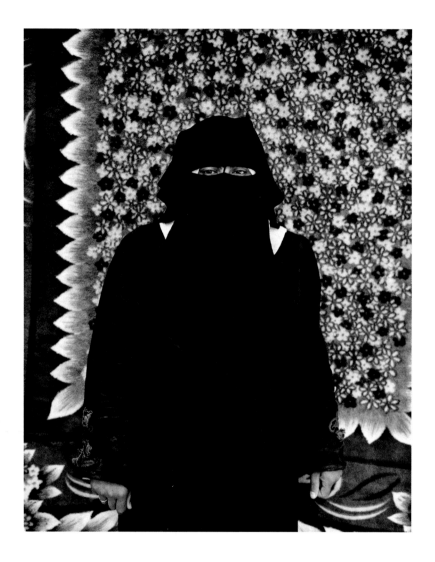

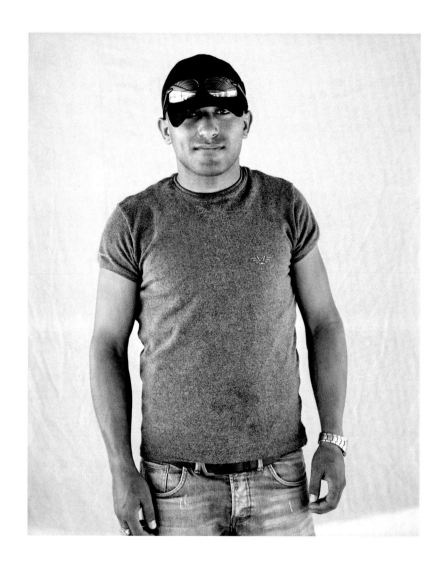

Miki Kratsman
Displaced (19), 2010
Digital pigment print

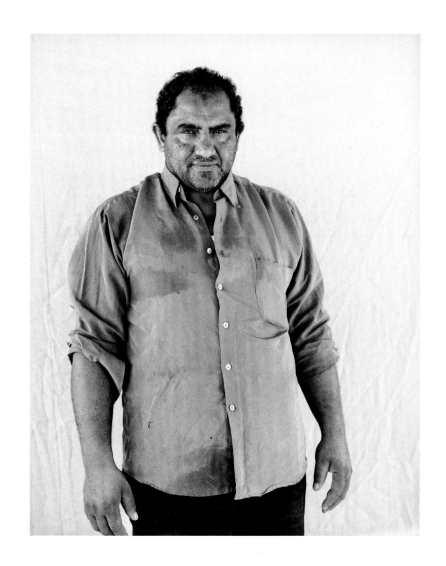

Miki Kratsman
Displaced (15), 2010
Digital pigment print

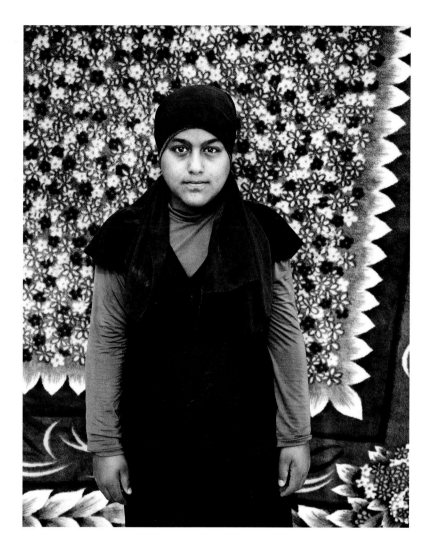

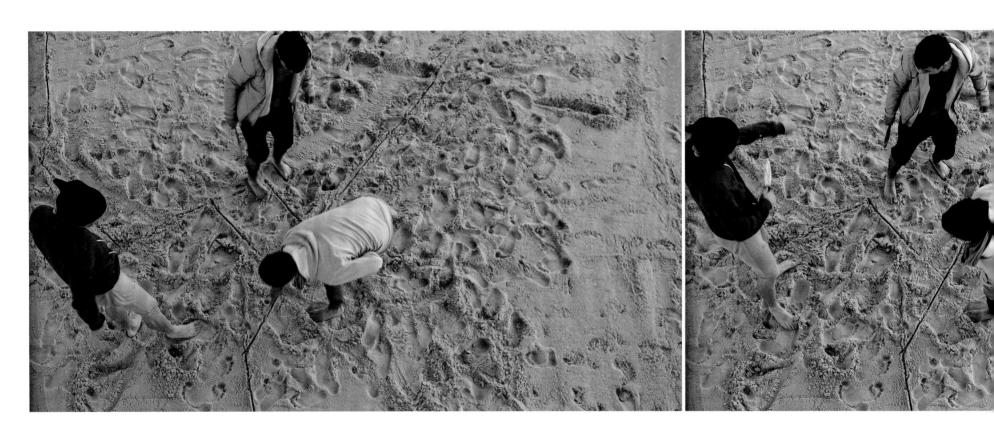

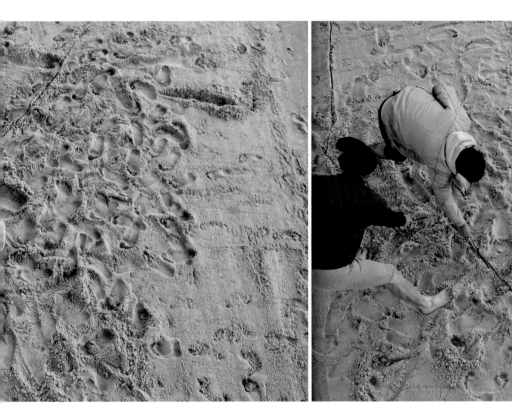
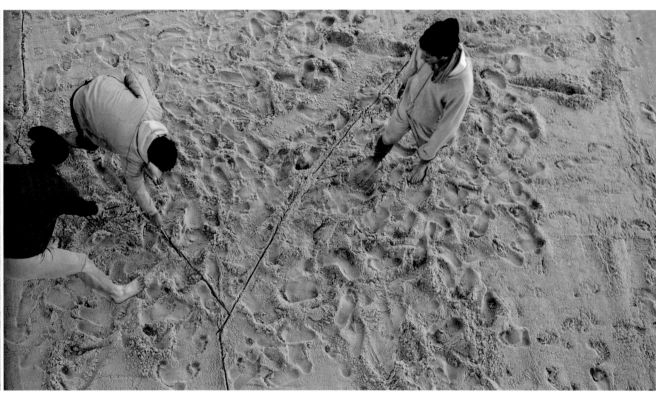

Adi Nes
Untitled (from the "Soldier" series), 1999
Chromogenic color print

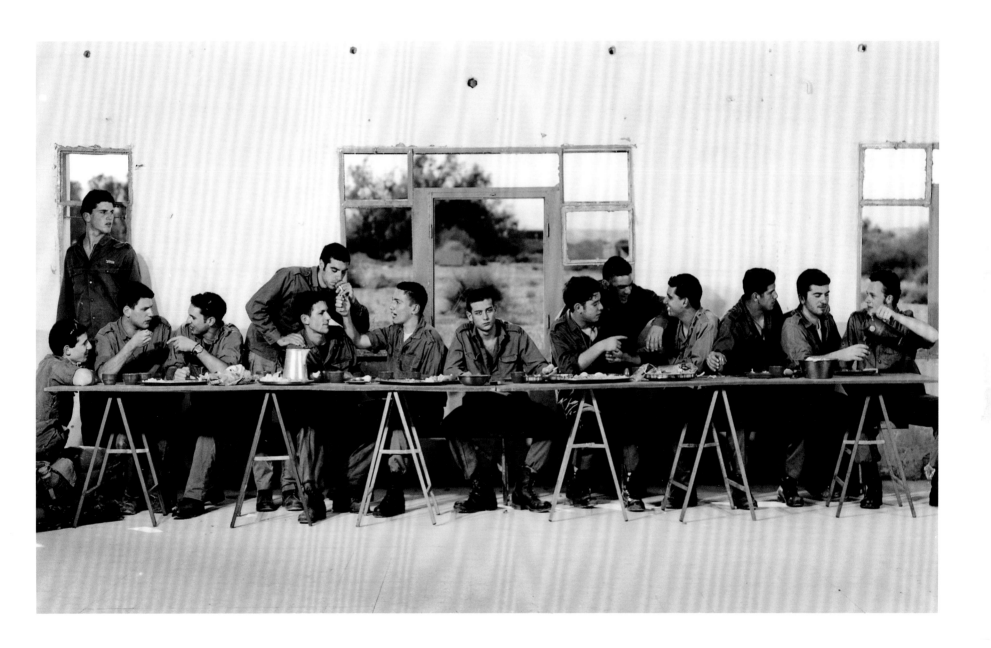

Adi Nes
Untitled (from the "Soldier" series), 2000
Chromogenic color print

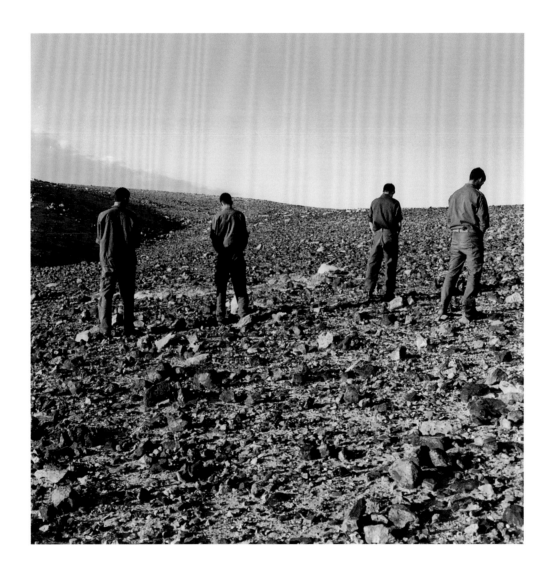

Nira Pereg
Sabbath, 2008
Video (color, sound), 7:12 minutes

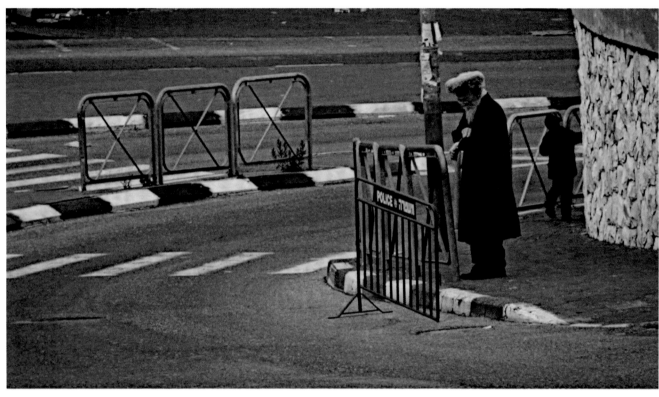

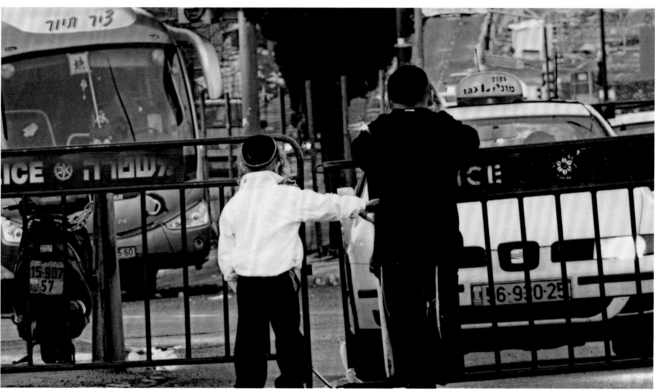

Gilad Ratman
The Boggy Man, 2008
Video (color, sound), 4 minutes

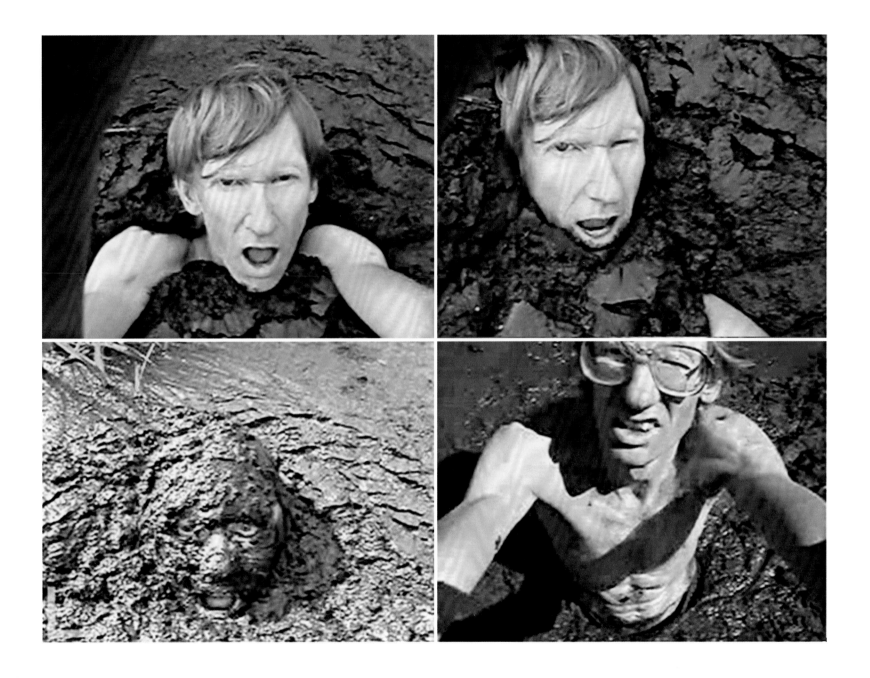

Michal Rovner
To Be a Human Being, 2007
Video (color, sound), 13 minutes

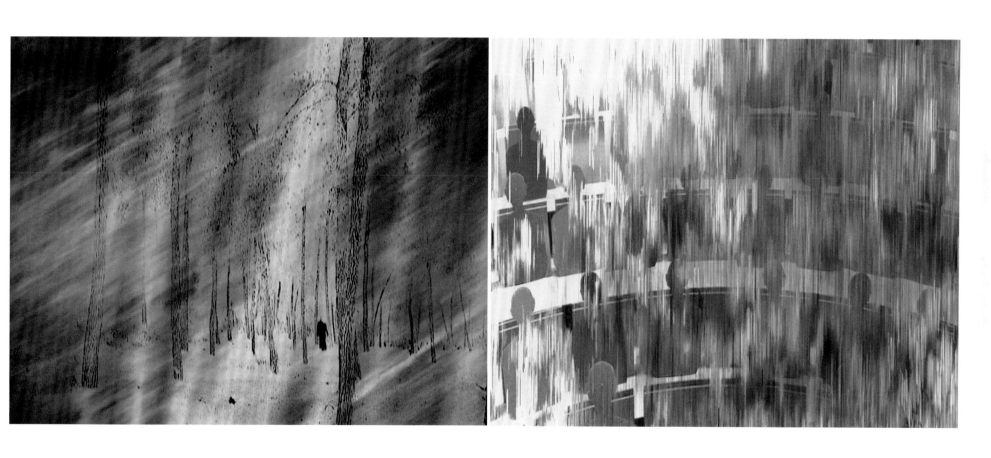

Sharon Ya'ari
Rashi Street, 2008
Archival inkjet print

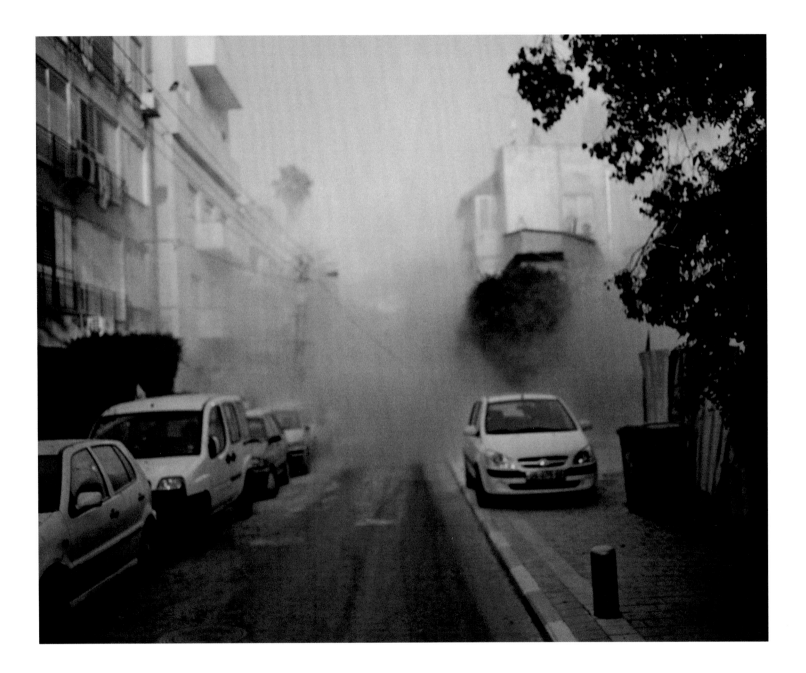

Sharon Ya'ari
Untitled, 2009
Archival inkjet print

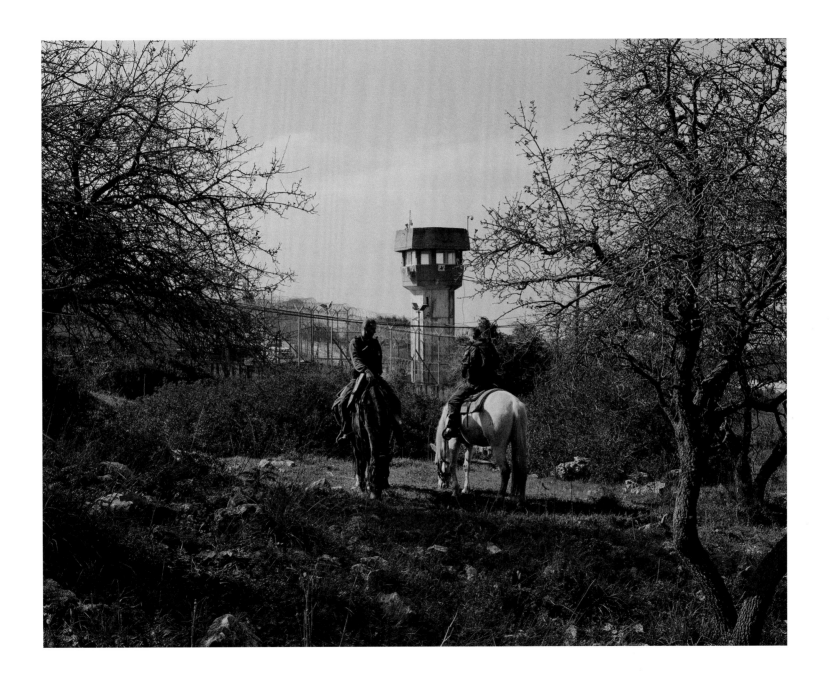

Sharon Ya'ari
Tel Aviv, 2010
Archival inkjet print

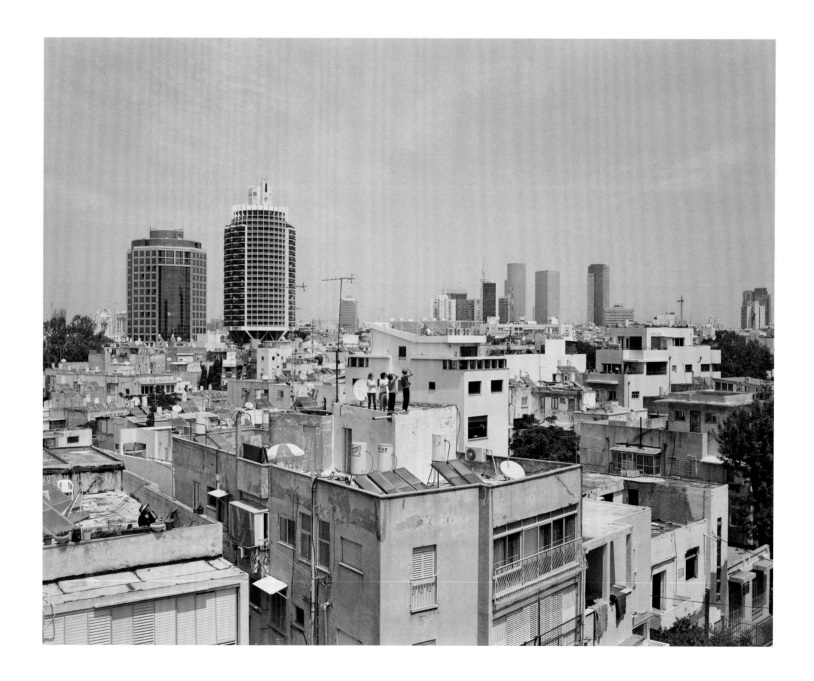

A screening section of the exhibition presents new and recent works by artists Dana Levy, Shahar Marcus, Lior Shvil, and Rona Yefman, permitting the inclusion of still other perspectives. The quartet of short videos regards the themes of The Compromised Land from a comedic point of view, in the case of Marcus and Yefman, and a poetic viewpoint, in the case of Levy and Shvil. All of the works, however, inevitably revolve around themes of geography, boundary, and sense of place.

Yefman recruits Pippi Longstocking, the "strongest girl in the world," for her video Pippi Longstocking at Abu Dis (2006–8). It was made in collaboration with Tanja Schlander, an activist and performance artist who appears as the beloved redheaded, pigtailed character created by Sweden's Astrid Lindgren in the 1940s. Yefman films Pippi's attempts to tear down the enormous concrete wall separating Israel from the Palestinian territories in East Jerusalem with her bare hands, an act that is both absurd and remarkably apt: she is a children's heroine as poster girl against Israel's Palestinian policies, encouraged by a few Palestinian women who are passing by. For Yefman, the rebellious, subversive Pippi is her alter ego.

Sabich (2006) by Shahar Marcus appears much less provocative, as he is shown making what is essentially a huge Middle Eastern pizza on the floor of his studio. One of the most popular street foods in Israel, by way of Iraq, sabich was originally most likely eaten to break the Sabbath fast. In Marcus's work, it is a historical reference as well as a metaphor for the highly interrelated cultures of the Middle East, as tangled as the ingredients he is tossing onto his pie. He compares his performance to ritualistic painting as well as to action painting on a pita canvas, parodying, paying homage, or both, to the Jackson Pollock film by Hans Namuth, the definitive documentary of an Abstract Expressionist at work.

Dana Levy's poetic meditation *The Fountain* (2011), with sound by Matthew Dotson, focuses on a fallen tree hoisted from the lake in which it was submerged, the winch briefly, tellingly visible. Pulled upward from the water, it is lifted slowly, then the action stops, the deracinated tree suspended in mid-air, twisting in space, its roots exposed, vulnerable. The image is both beautiful and disquieting, the meaning ambiguous, but suggestive of transition, an old order yielding to whatever might be next. The drawn-out notes of the audio track are soothing but rather elegiac. They are relieved, however, by the replacement of the monochromatic dawn with the clear colors of a tranquil sunlit day.

Lior Shvil's video animation, *DessertLand* (2008), surveys an Israeli military base. The silhouetted camp is slowly exposed by a nocturnal searchlight moving along its perimeters, the gaze directed toward the wired barriers that separate the inside--where the viewer is located--from the outside world, which is indicated by distant lights, by the moon. Failing to pierce the blackness, the searchlight offers no solace; the areas it spotlights conjure a fantasy realm populated by tiny soldiers, a dancer, a centaur, and other creatures that invade the reality of a routine military patrol. The viewer who peers into the ominous dark is also the soldier who stands guard over a nation in peril who, Shvil seems to say, escapes into a dreamy world of make-believe when reality becomes unbearable.

--Lilly Wei

Dana Levy
The Fountain, 2011
Video (color, sound), 2:46 minutes

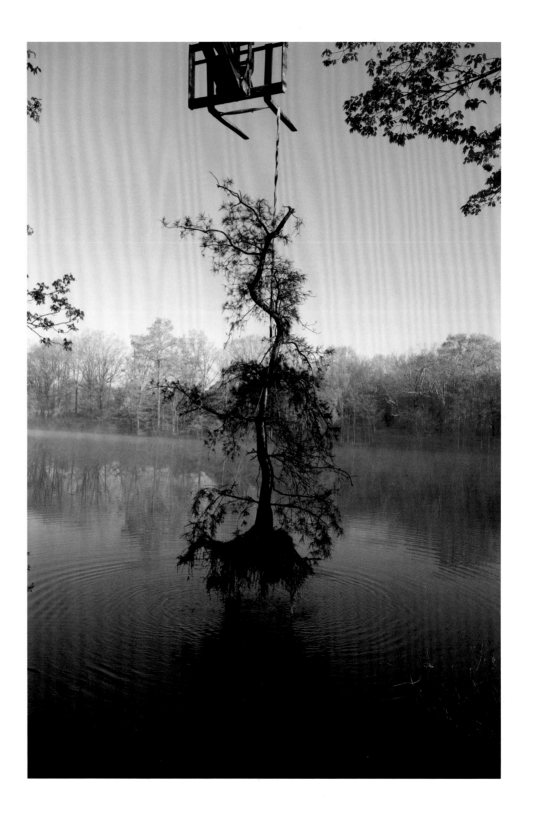

Shahar Marcus
Sabich, 2006
Video (color, sound),
4:35 minutes

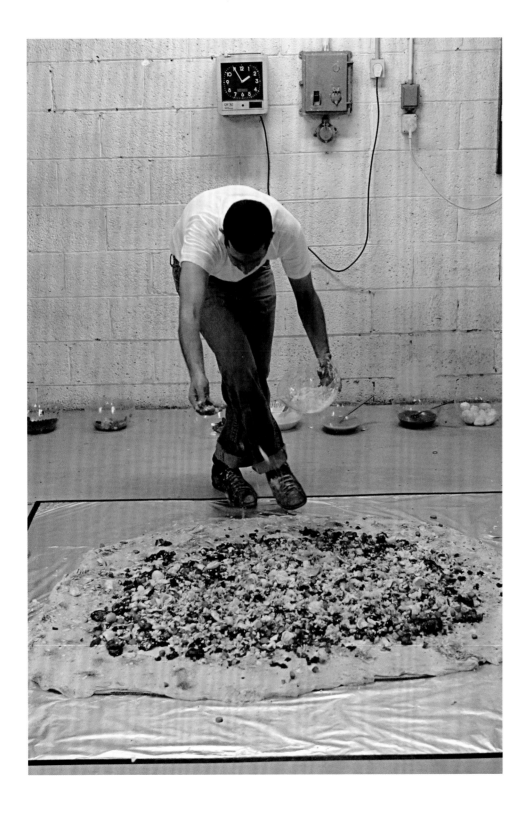

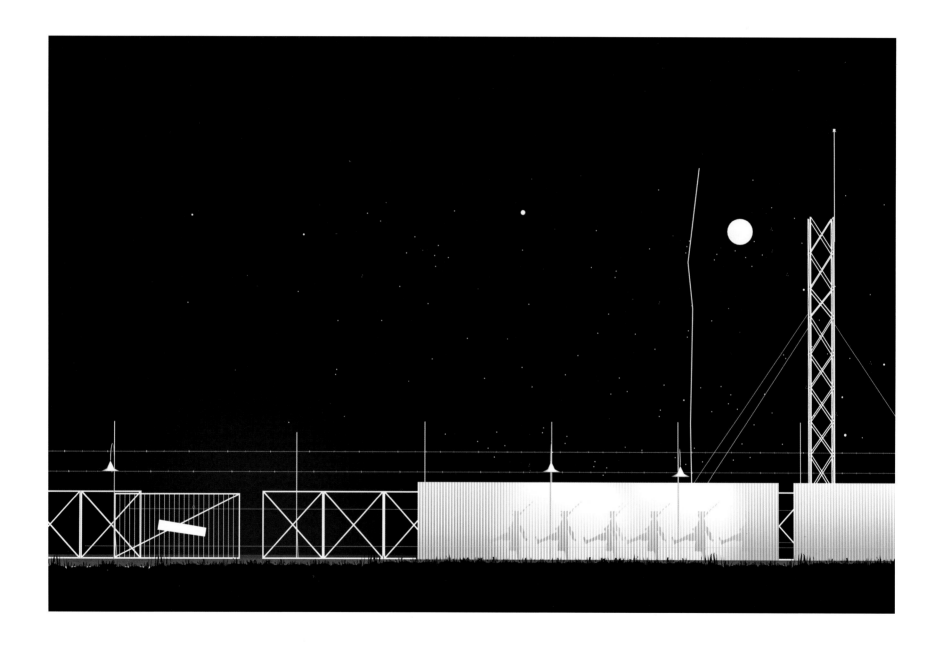

Rona Yefman and Tanja Schlander
Pippi Longstocking at Abu Dis, 2006–8
Video (color, sound), 3:50 minutes

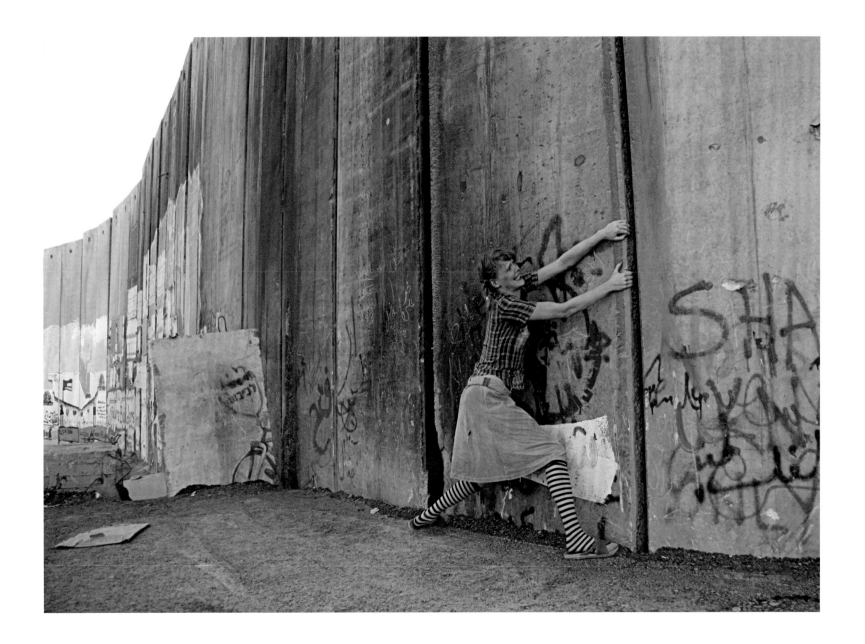

CHECKLIST

Boaz Arad

Kings of Israel, 2009
Video (color, sound), 9:30 minutes
Collection of the artist

Boaz Arad and Miki Kratsman

Untitled, 2003
Video (color), 40 minutes
Collection of the artists

Yael Bartana

Trembling Time, 2001
Video (color, sound), 6:20 minutes
Courtesy Sommer Contemporary Art,
Tel Aviv

Mary Koszmary (Nightmares), 2007
16mm film transferred to video
(color, sound), 10:50 minutes
Courtesy Sommer Contemporary Art,
Tel Aviv

Joseph Dadoune

Ofakim, 2010
Video (color, sound), 14:47 minutes
Collection of the artist

Nir Evron

In Virgin Land, 2006
Video (black-and-white, sound),
12 minutes
Narration by Yossi Alfi
Courtesy Chelouche Gallery for
Contemporary Art, Tel Aviv

Barry Frydlender

Shirat Hayam ("End of Occupation?"
Series #2), 2005
Chromogenic color print
59 ¾ x 131 inches
Edition of 8
Collection of Casey and Ellen Cogut

The Visit (Nazareth), 2011
Chromogenic color print
47 ¼ x 75 ¾ inches
Edition of 5
The Lewkowitz Family Collection

Dani Gal

Nacht und Nebel (Night and Fog), 2011
Video (color, sound), 22 minutes
Courtesy Freymond-Guth Fine Arts,
Zurich

Ori Gersht

Neither Black nor White, 2001
Video (color, sound), 4:45 minutes
Courtesy of the artist and CRG
Gallery, New York

Pomegranate, 2006, produced 2007
Digital video (color, sound),
3:52 minutes
13 ⅛ x 28 ⁷⁄₁₆ x 5 inches
The Jewish Museum, New York
Purchase: Nathan and Jacqueline
Goldman and Simon Lissim Funds,
by exchange, 2008-219

Dor Guez

July 13, 2008–9
Video (color, sound), 13:18 minutes
Courtesy of the artist and Dvir
Gallery, Tel Aviv

(Sa)Mira, 2008–9
Video (color, sound), 13:40 minutes
Courtesy of the artist and Dvir
Gallery, Tel Aviv

Oded Hirsch

Habaita, 2010
Video (color, sound), 2:10 minutes
Courtesy Thierry Goldberg Gallery,
New York

Tochka, 2010
Video (color, sound), 13:20 minutes
Courtesy Thierry Goldberg Gallery,
New York

Miki Kratsman

Displaced (5), 2010
Digital pigment print
35 ½ x 43 inches
Courtesy Chelouche Gallery for
Contemporary Art, Tel Aviv

Displaced (7), 2010
Digital pigment print
35 ½ x 43 inches
Courtesy Chelouche Gallery for
Contemporary Art, Tel Aviv

Displaced (10), 2010
Digital pigment print
35 ½ x 43 inches
Courtesy Chelouche Gallery for
Contemporary Art, Tel Aviv

Displaced (11), 2010
Digital pigment print
33 ½ x 27 ½ inches
Courtesy Chelouche Gallery for
Contemporary Art, Tel Aviv

Displaced (12), 2010
Digital pigment print
33 ½ x 27 ½ inches
Courtesy Chelouche Gallery for
Contemporary Art, Tel Aviv

Displaced (15), 2010
Digital pigment print
33 ½ x 27 ½ inches
Courtesy Chelouche Gallery for
Contemporary Art, Tel Aviv

Displaced (19), 2010
Digital pigment print
33 ½ x 27 ½ inches
Courtesy Chelouche Gallery for
Contemporary Art, Tel Aviv

Sigalit Landau

Azkelon, 2011
Video (color, sound), 16:32 minutes
Courtesy of the artist

Dana Levy

The Fountain, 2011
Video (color, sound), 2:46 minutes
Original soundtrack by Matthew
Dotson
Courtesy Braverman Gallery, Tel Aviv

Shahar Marcus

Sabich, 2006
Video (color, sound), 4:35 minutes
Courtesy Braverman Gallery, Tel Aviv

Adi Nes

Untitled (from the "Soldier" series),
1999
Chromogenic color print
52 x 86 inches
Courtesy of the artist and
Jack Shainman Gallery, New York

Untitled (from the "Soldier" series),
2000
Chromogenic color print
58 x 59 inches
Collection Danny First, Los Angeles

Nira Pereg

Sabbath, 2008
Video (color, sound), 7:12 minutes
Courtesy Braverman Gallery, Tel Aviv

Gilad Ratman

The Boggy Man, 2008
Video (color, sound), 4 minutes
Courtesy Braverman Gallery, Tel Aviv

Michal Rovner

To Be a Human Being, 2007
Video (color, sound), 13 minutes
Courtesy of the artist and
Yad Vashem, Jerusalem

Lior Shvil

DessertLand, 2008
Video animation (color, sound), 8
minutes
Music and sound by Dani Meyer
Courtesy of the artist

Sharon Ya'ari

Rashi Street, 2008
Archival inkjet print
62 x 76 inches
Courtesy Andrea Meislin Gallery,
New York

Untitled, 2009
Archival inkjet print
41 x 52 inches
Courtesy Andrea Meislin Gallery,
New York

Tel Aviv, 2010
Archival inkjet print
33 x 27 ½ inches
Courtesy Andrea Meislin Gallery,
New York

**Rona Yefman and
Tanja Schlander**

Pippi Longstocking at Abu Dis, 2006–8
Video (color, sound), 3:50 minutes
Courtesy Sommer Contemporary Art,
Tel Aviv

ARTISTS' INFORMATION

For further information please see the following websites:

Boaz Arad

Born 1956 in Afula, Israel.
Lives and works in Tel Aviv.
http://www.boazarad.net/

Yael Bartana

Born 1970 in Kfar Yehezkel, Israel.
Lives and works in Tel Aviv and Berlin.
http://www.petzel.com/artists/
yael-bartana/

Joseph Dadoune

Born 1975 in Nice, France.
Lives and works in Ofakim, Israel.
http://www.josephdadoune.net/

Nir Evron

Born 1974 in Herzliya, Israel.
Lives and works in Tel Aviv.
http://www.nirevron.com/

Barry Frydlender

Born 1954 in Tel Aviv.
Lives and works in Tel Aviv.
http://www.andreameislin.com/
artists/barry-frydlender/

Dani Gal

Born 1977 in Jerusalem.
Lives and works in Berlin.
http://www.artiscontemporary.org/
artist_detail.php?id=144

Ori Gersht

Born 1967 in Tel Aviv.
Lives and works in London.
http://www.crggallery.com/artists/
ori-gersht/

Dor Guez

Born 1982 in Jerusalem.
Lives and works in Jaffa, Israel.
http://www.artiscontemporary.org/
artist_detail.php?id=87

Oded Hirsch

Born 1976 in Kibbutz Afikim, Israel.
Lives and works in New York.
http://www.odedhirsch.com/

Miki Kratsman

Born 1959 in Buenos Aires.
Lives in Tel Aviv and works throughout
Israel.
http://www.chelouchegallery.com/
artistWorks.php?id=49

Sigalit Landau

Born 1969 in Jerusalem.
Lives and works in Tel Aviv.
http://www.sigalitlandau.com/

Dana Levy

Born in Tel Aviv.
Lives and works in New York.
http://www.danalevy.net/

Shahar Marcus

Born 1971 in Petach Tikva, Israel.
Lives and works in Tel Aviv.
http://www.shaharmarcus.com/

Adi Nes

Born 1966 in Kiryat Gat, Israel.
Lives and works in Tel Aviv.
http://www.jackshainman.com/artist-
images31.html

Nira Pereg

Born 1969 in Tel Aviv. Lives and works
in Tel Aviv.
http://www.nirapereg.net/

Gilad Ratman

Born 1975 in Haifa, Israel.
Lives and works in Tel Aviv.
http://www.bravermangallery.com/
page.php?id=12

Michal Rovner

Born 1957 in Tel Aviv.
Lives and works in New York and
Kfar Shmuel, Israel.
http://www.pacegallery.com/
artists/405/michal-rovner

Tanja Schlander

Born 1974 in Roskilde, Denmark.
Lives and works in Copenhagen.
http://dallasbiennial.org/volume-2/
bjorn-ross-selections/tanja-
schlander-kussen/

Lior Shvil

Born 1971 in Tel Aviv.
Lives and works in New York.
http://www.artiscontemporary.org/
artist_detail.php?id=123

Sharon Ya'ari

Born 1966 in Holon, Israel.
Lives and works in Tel Aviv.
http://www.sharonyaari.com/

Rona Yefman

Born in Haifa, Israel.
Lives and works in New York.
http://www.artiscontemporary.org/
artist_detail.php?id=28

Photography Credits